COLOR MIXING
in ACTION

Books by Helen Van Wyk
Casselwyk Book on Oil Painting
Acrylic Portrait Painting
(out of print)
Successful Color Mixtures
Painting Flowers the Van Wyk Way
Portraits in Oil the Van Wyk Way
Basic Oil Painting the Van Wyk Way
(Revision of Casselwyk Book on Oil Painting)
Your Painting Questions Answered from A to Z
Welcome to My Studio
Color Mixing in Action

COLOR MIXING in ACTION

HELEN VAN WYK

ART INSTRUCTION ASSOCIATES 2 Briarstone Road, Rockport, MA 01966

COLOR MIXING IN ACTION

Editor: Herbert Rogoff
Design: Cathy Gale
Production: Cathy Gale
Photography: Clark Linehan

Copyright ©1990 Helen Van Wyk
All rights reserved
Published by Art Instruction Associates
2 Briarstone Road
Rockport, MA 01966

ISBN 0-929552-06-7

table of contents

lessons

paintings by helen van wyk

paintings by helen van wyk

TV / Indicates painting done on the series
Welcome to My Studio

*Indicates painting in private collection

introduction

The book you are holding in your hands is the eighth one that I have written and had published by *Art Instruction Associates.* With each one, the problem has been the same — *how to start.*

This time I have the problem solved, much to my relief and much to your good fortune. My introduction is in the words of a very special individual, one very dear to me.

During the 1940s, I was privileged to have studied with Maximilian Aureal Rasko (he preferred the appellation M.A., but to me he will *always* be Rasko). It is his teaching that is the foundation of all the thoughts and conclusions that I have come to realize about painting.

Sometime during that decade (I can't remember the exact year), Rasko wrote an article for *Design* Magazine entitled "The Limitations on Genuine Artistic Expression." I've chosen to reprint some portions of this article to make it possible for you to share his wisdom. In these excerpts, you will see how fundamental his approach was; how profound he was within his simple analysis of painting.

"Let's face a few basic facts. If we are to understand the meaning of the word 'art,' and that part of it which is termed the *two dimensional surface expression,* we ought to know the limitations of those humans who produce it.

"Imagination is definitely not limitless. Nothing enters the human mind for knowledge or conclusions which are passively retained or put into action without first having been experienced through one of our five senses. If you, as an artist, are engaged in producing a two dimensional surface expression, regardless of your medium, you must have first had some contact with what you are trying to express.

"It is vital that an artist who is engaged in producing this kind of work have a good memory— have the ability to remember shapes, tone and color. We can produce a visible image *with* or *without color,* but never without shape and tonality. This recalling of shapes and the relative relationship of one shape to another is what causes our eyes to see and then our brain to comprehend.

"Of all our senses, sight is the most *aware.* Sight warns us of danger, stimulates our appetite, influences our sensations of touch and smell and helps translate the sounds we hear. But even the marvelous organ which is our eyes has its limitations. We can see intelligibly to a limited distance, cannot distinguish without light being present and can perceive only the three primary colors which originate from sunlight, and their complementaries.

"More important to an artist, we can see only the five different shapes that nature has created — no more and no less. These shapes are the sphere, cube, trylon, cone, and cylinder. Regardless of what we see, all shapes stem from these five. It required a Plato to first understand this and put it down, and until the relative present nobody has sought to refute this law of nature. (So-called modernists who would have us believe otherwise are only playing games at the expense of a credulous public.)

"We should not lose sight of the limitations that exist under nature's ordered plan. No human can see colors that are not there; he cannot invent new shapes. At best, he can only combine, rearrange and vary the combinations of these physical factors. Nature has created and man must imitate, even if poorly by comparison. And it is the artist who enacts this important role, for until he translates an experience into a visible interpretation, it cannot exist for the viewer.

"Just how good or bad is interpretation may be depends simply on the artist's ability, dexterity or facility with a material. When we come face to face with these absolute limitations on perception and translation, we must then face an inescapable conclusion: all two dimensional surface means of expression, though limited, remain the best means of communicating with our fellow man short of language itself.

"There are three important approaches to self-expression as an artist: 1) by past experience simply reflected; 2) by past experience translated into emotion; 3) by past experience critically assembled. You can thus be a reporter of what you see, a commentator who dramatizes or a translator of past experience who applies this to create other, possibly imaginative experiences. By these three means we can bring our message to the viewer by our work itself, without printed explanations being necessary.

"It is possible, of course, to produce art which combines all of these approaches.

"Never underestimate the challenges of nature as it exists; there is far more than a lifetime of experimenting ahead for any artist who would seek to catch nature with his brush. And there is mental stimulation in this struggle to express yourself. The thinking and dexterity which are necessary to produce even a poor expression is still a worthwhile manifestation of an individual's intellect. It makes little difference whether art is practiced by a child or an adult—just so long as it *expresses* something valid, the degree of excellence is of no consequence."

Dear Rasko alerted me to the *seven components of the two dimensional surface expression.* They are:

1. Motivation
2. Composition or design
3. Shapes or drawing
4. Tonal contrasts
5. Brushwork
6. Lines or edges of shapes
7. Color

They have been the foundation of my teaching of painting. I have defined them and have taught how they are the working parts of every painting's appearance, regardless of subject matter.

I have stressed that of the seven components, color is one that can be omitted without diminishing the possibility of pictorial self expression. As Rasko wrote in his article, "We can produce an image with or without color." Then why an entire book on color mixing? Because you can't ignore its existence. We can be emotionally and visually impressed by artists' etchings, engravings, sketches and tonal renderings, but when we see black and white reproductions of paintings, we feel cheated and denied of the element of color. When Mallory, the famous mountain climber, was asked why he climbed Mt. Everest, his answer was "because it's there." And that's the same answer to the question, "Why an entire book on color mixing?"

Color is a glorious part of our existence, and to record it at all means to record it as convincingly as we see it in nature and as beautifully as we are impressed by it. Nature's color is translated by artists with color mixtures, and they actually execute and create their paintings. Those other six components are hiding out in color mixtures, only to be unleashed onto a canvas by application.

So this book on color mixing becomes necessary. I'm sure it will help you see colors with more understanding and enable you to mix and apply colors with more satisfaction and success.

Helen Van Wyk
Rockport, Massachusetts

a more practical color wheel

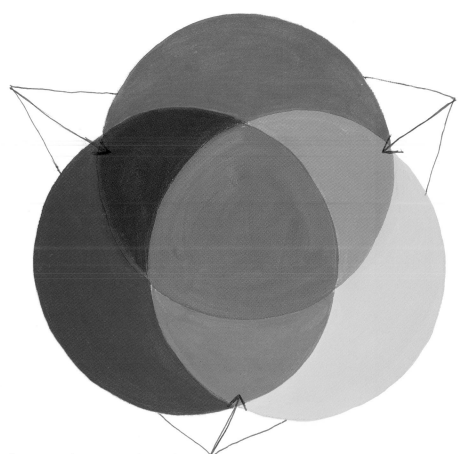

In order to make your color mixtures as beautiful and as natural looking as you see them, you have to learn, and appreciate, the character of color. Your study doesn't have to be scientific or even profound, just a simple understanding of the very presence of color.

Let's start with the painter's *three primary colors: yellow, red* and *blue*, as seen in my version of a color wheel (in the physicist's "color wheel," the primary colors are *magenta, yellow-green* and *turquoise*). Where these colors meet and mix, three other colors appear. They are *violet, green* and *orange*, and are called, for obvious reasons, the *secondary* colors.

In the center of this strange-looking formation, we see colorless gray. This is the area where the three primaries meet and mix. The light we see by and the lighting that affects everything we see is a mixture of the three primaries. The choice of gray to represent the ever-presence of the three primaries is a compromise between color in light and color in paint. In light, the three primaries make a colorless light; in paint, the three primaries combine to make a colorless dark.

What does all this have to do with color mixing?

It's fundamental. Nature's light is made of three colors and they influence everything we look at. If nature paints her world with three colors, we have to use three colors, too. We do so by using a color with its complement.

Red's complement is green, the mixture of yellow and blue.

Yellow's complement is violet, the mixture of red and blue.

Blue's complement is orange, the mixture of red and yellow.

You can see that a color plus its complement is a combination of the three primary colors. All three are needed to record nature's balanced color.

When a color is not balanced, it looks wrong, harsh, flat or unnatural. Our record on canvas of nature's balanced colors can be made by using this formula: Balance a color with its complement. Used in concert with each other, they will pay a compliment to each other and to your painting. All the chapters of *Color Mixing in Action* point out the use of colors and their complements and how they record subjects realistically.

warm and cool color

yellow

orange

red

violet

blue

green

We have all experienced the joy of seeing a rainbow. It's a time when nature proves that light is made up of color. When we see a rainbow, we can only see the front half of it. Actually, a rainbow is a circle of color and that's why the spectrum colors are always diagrammed in the form of a wheel, putting colors and their complements on opposite arcs of the wheel.

This diagram of the spectrum starts with yellow, orange and red—the warm colors—and continues to violet, blue and green—the cool colors. Warm yellow's complement is cool violet; the complement of the hottest color—orange—is the coldest color—blue; and warm red's complement is cool green. In color mixing, it's important to be able to recognize the temperature of color because a color that is too hot or too cold is a wrong mixture. Colors with their complements strike the balance of temperature that color mixtures need to be natural looking.

This is all well and good, you may say, but how do I fit it into practical application? It appears that all of this has nothing to do with making grass color, skin color or sky color, to name a few. I cannot predict, imagine, or know what subject you want to paint, or how you want to interpret your subjects, nor do I know what light you'll see your subjects in. How then could I think that just giving you color mixtures would be sufficient color mixing instruction? Learning the principles of color will help you make your own color interpretations instead of relying solely on color formulas. All of my suggested color mixtures should only act as guides not as absolute color solutions.

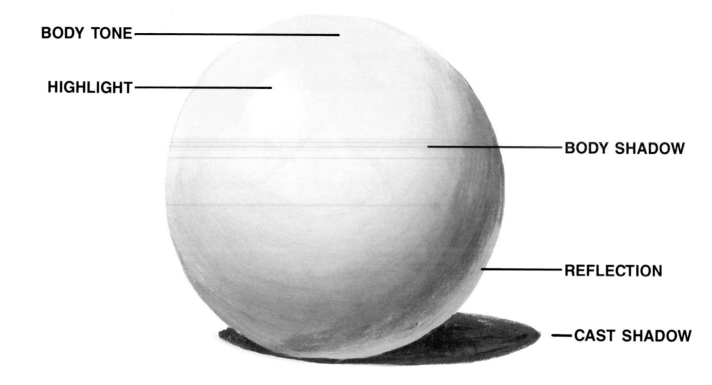

BODY TONE —————————————————

HIGHLIGHT —————————————————

BODY SHADOW

REFLECTION

CAST SHADOW

dimensionalizing your color

Light in this world has *three major characteristics.* You have just learned that light is our *source of color.* Another important one is that it *travels in a straight line.* If it didn't, it would be able to go around a corner, thereby robbing us of the contrast of light and shade. Finally, the factor that seems almost too obvious to mention but is so important to pictorial interpretation: in our world we have *only one source of light.* Just imagine how different everything would look if there were two suns coming up every day, one from the east the other from the west. Aren't you glad that you only have to learn how to paint the contrasts caused by *one* source of light that travels in a straight line?

One source of light makes five tone values appear. Seeing how they affect a ball is the best way to begin an appreciation of how important they are in painting. Being able to recognize and paint the five tone values caused by one direct source of light is the way to impose this three-dimensional world on a mere two-dimensional surface.

Every single area of a painting should simply be one of these five tone values. All these values have to be colored. The tone of a color is the most important consideration in color mixing. If the tone is not right, the color will look wrong. You have to address your color mixtures to record the tone the color happens to be in its lighted or shaded condition.

Throughout this book, I constantly use the names of the five tone values to describe areas of coloration. Sometimes, I'll use the term *mass tone;* it refers to a subject's general, overall color. A mass tone establishes a shape on which a body shadow can be added with a darker tone, and a body tone can be imparted by adding a light tone. I have been known to say, "You can paint anything dimensionally by massing it in (in a beautiful shape) and adding lighter and darker tones to it."

1

THE COLORS OF MY PALETTE

You have just examined the properties of the colors of nature. Now I'm going to tell you about the properties of the paint you'll use to record them.

I think it's a miracle that we have physical substitutes for colored light. Ever since the caveman, stuff has either been found or made that can emulate the effect of transparent light rays.

The six colors of the spectrum—yellow, orange, red, violet, blue, green—form the classification of all the tubes of paint you can buy. There are many to choose from. The paint versions of these six colors, and admixtures of them, vary in three ways: **tone, intensity and hue.** In *tone*, from light to dark; in *intensity*, from bright to dull; and in *hue*, which I use to explain that all six colors of the spectrum can tend towards its neighboring color. For instance, yellow can tend toward green or toward orange, and red can tend toward orange or violet. The hue of a color determines, too, its temperature: a greenish yellow is cooler than an orangey yellow, and a reddish orange is warmer than a reddish violet. Recognizing these *three factors of color* is important to mixing colors correctly.

Even if you squeeze out a little of every tubed color available, you still could not make your mixtures actually become the colors of the things you see. You have to rid yourself of that impossible assumption. Once you realize it, you are no longer inhibited, intimidated or afraid of mixing colors. Instead, you can be inspired to search out mixtures that might look, and work, well together. Color mixing, after all, is not a definite science; it's an experimental process that produces a color presentation.

From all the tubed colors on the market, I have chosen these colors for my palette because they are not only adequate but efficient as well.

White

Thalo Yellow Green
Cadmium Yellow Light } A range of cool to warm
Cadmium Yellow Medium bright, light yellows

Cadmium Orange
Cadmium Red Light } A range of warm to cool
Grumbacher Red bright, light reds
Thalo Red Rose

Yellow Ochre Darker, duller versions of
Raw Sienna } the warm colors — yellow,
Light Red (English Red Light) orange, red

Burnt Umber } Even darker, duller versions
Burnt Sienna of the warm colors, yellow,
Indian Red orange, red

Alizarin Crimson
Manganese Violet
Thalo Blue } A range of dark but brilliant
Sap Green cool colors — violet, blue, green
Thalo Green

Ivory Black } Used with white to make
 tones of gray

Shown here are warm tubed yellows, oranges and reds that offer an adequate range of tone from light to dark, and intensity from bright to dull.

some tubed warm colors

cadmium yellow light

cadmium yellow medium

cadmium orange

cadmium red light

yellow ochre

raw sienna (orange)

light red

**raw umber
(yellow orange)**

burnt umber (yellow)

burnt sienna (orange)

indian red

some tubed cool colors

Shown here are cool tubed violets, blues and greens. Tones of cool colors are made by their admixture with white. Their intensities are controlled by their admixture with gray.

alizarin crimson

thalo red rose

manganese violet

thalo blue

cerulean blue

cobalt blue

ultramarine blue

thalo green

sap green

thalo yellow green

brushes

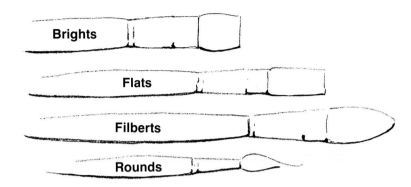

Brights

Flats

Filberts

Rounds

At every lecture I give, I never fail to quote that wise person who said, "Start with a broom and finish with a needle." In a nutshell, this cautions the painter to see his subject and composition in large masses of color, leaving details and some other artistic development for later. I can't emphasize the importance of this statement strongly enough since it is the tendency among many students to want to finish a painting *with a beginning.* You can avoid this pitfall by starting with large brushes. Here are some examples of what a "broom" can do for you:

1. Mass in an *entire tree* in a general shape before trying to paint leaves.

2. Establish the shape of an *eye socket* before painting the iris and highlight of the eye.

3. Mass in the overall shapes of a *bunch of grapes* before painting each individual grape.

I'm sure, at this point, you're asking, "Which brushes are brooms and which ones are needles?" Here are brushes that I consider essential for general painting:

For the beginning stages of your painting:
Bristle-type, Brights, flats or filberts: Numbers 10, 12, 14

For the developing stage of your painting:
Bristle-type, Brights and filberts: Numbers 6 to 9

For the final stages of your painting:
Bristle-type, Brights and filberts: Numbers 2 to 5

You will not go wrong with the brushes I've just listed. Of course, there are brushes that are made for special effects, and you will find great use for some of them:

1. A *Hake,* or large duster-type brush for blending (you were born with an efficient—and inexpensive —blender: your thumb).

2. Some small round brushes for details of dark tone and for signing your name.

3. A *script* brush (popularly referred to as a "rigger") for calligraphy.

4. When you feel some confidence in front of your easel and notice that your brush, your paint and the feel of the canvas are working together, treat yourself to some *red sable* brushes: Brights, numbers 4, 6, 8, 10, 12. Quite an investment, I know, but these brushes will awaken you to brushwork that can't be done with any other instrument. Your artistic efforts deserve some self indulgence. And if you feel you want to justify this extravagance, you'll find that your set of red sables will offer you more satisfaction than many other costly pleasures.

I have to accompany this list of "special effect" brushes with some words of caution: If your brushwork identifies the brush rather than the subject that it's recording, your brushwork can be classified as "gimmicky." Your painted picture should portray the subject beautifully, not advertise the brush that did it. The brushwork of the paintings you see in museums fills you with "wonderment" and awe. So, please—don't be addicted to a brush or a knife just for effects. Incidentally, this is one of the reasons I don't like fan blenders and will never use them.

I guess you've noticed that painting does impose some wear and tear on brushes, but, in truth, most brushes are ruined by not cleaning them properly or by neglecting to clean them at all.

Paint in brushes will only wash out with turpentine immediately after a painting session. Putting your brushes aside for later is a bad habit to fall into; very often, "later" never comes. As reluctant as I am to use the word "always" in regard to my painting, I will use it here: I *always* take time to wash my brushes out with turpentine after every painting session by sloshing them in a coffee can half filled with turpentine, being careful not to grind the bristles down on the bottom of the can. When I know I won't be at the easel the next day, then, into another can, I mix warm water and liquid detergent (in a ratio of 4 parts water to one part detergent) and slosh my brushes to wash out the dirty turpentine. After rinsing them with clear water, I smooth out the ends of my brushes with my fingers and set them aside to dry.

Another way to extend the life of your brushes is to use a lot of paint. Trying to make a little bit of paint go a long way will wear a brush down and, I might add, wear away the possibility of a good painting too.

2

THE IN-THE-BEGINNING OF COLOR MIXING

Now that you have become acquainted with the *basics of color*, don't let them overwhelm you. As is true when mastering anything, color mixing, too, can be learned in simple stages. The best place to start being better "color mixers" is to learn a way to mix the right color of things, such as skies, skin, trees, apples, sunlight, and on and on. The *way* is to sneak up on a good mixture, one that records the important color characteristics of a subject's appearance. Let's take them one at a time:

First, you have to see all the colored things in this world as versions of the *spectrum colors*. Many of these are obvious: *Blue* sky, *red* apple, *yellow* lemon. Many objects, however, are not colored as obviously. Identifying them as spectrum colors, then, is more difficult. For example, what spectrum colors are the following: Copper, wood, skin, silver, rust, rocks, sand, clouds? You *have* to record them as colors because your palette does not have *copper* color, *wood* color, *rust* color, etc. Your palette only has *versions of spectrum colors* on it, and these objects' colors are hiding out in them. Copper is an *orange;* wood is a *yellow;* rust is a *red*. As painters, you must identify your subjects' colors. That's a beginning.

Next, you have to inspect the *tone* of the color that you have decided the subject is, meaning how light or dark the subject's color looks in its surroundings.

Another consideration is the color's *intensity*, which describes a color as bright, brilliant, dull or drab. Students often confuse intensity with tone, but when you realize that a color can be light and *bright* — like a lemon — or light and *dull* — like yellow beach sand you'll refrain from making this mistake.

The final characteristic to analyze about a subject's color is its *hue*. This is the subtlety of the color. To illustrate, a flesh color that is orange in color, light in tone, medium bright in intensity, can be reddish in hue or more yellowish in hue. The hue of a color also describes its temperature. An example of this is a yellow brass color that is greenish in hue is *cooler* than yellow brass that looks yellow-orange in hue.

By defining the four characteristics of a subject's color, you will be able to mix a suitable color. You'll have to ask yourself four questions when faced with painting any subject. Here they are:

1. **Q.** What color do I see?
 A. It has to be one of these six: Yellow, orange, red, violet, blue or green.

2. **Q.** What tone is the color?
 A. It is light, medium or dark in contrast to its surroundings.

3. **Q.** What intensity is the color?
 A. It is bright, medium or dull.

4. **Q.** What hue is the color?
 A. It is a warm version of the color or it is a cool version of the color.

I'm using the color yellow to show you how this *way* of color mixing works, since yellow is such a prevalent color. I hope you'll understand that yellow is everywhere, from wood to blonde hair, from sand to bare trees, from gold to an old, tear-stained love letter.

4 key color mixing questions

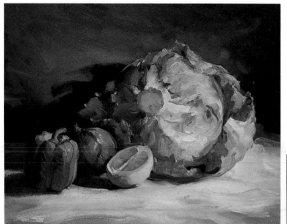

1. what color is it?
2. what tone is it?
3. what intensity is it?
4. what hue is it?

**look
analyze
mix
adjust
paint**

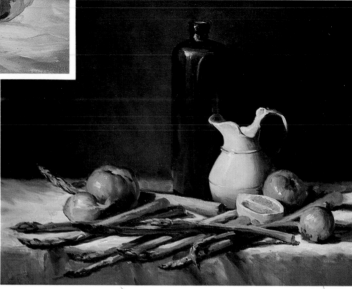

The 4 Questions Answered

1	Orange / dark / dull / orange	*warm*
2	Green / light / bright / yellowish	*warm*
3	Violet / dark / bright / reddish	*warm*
4	Green / medium dark / medium bright / slightly yellow	*warm*
5	Yellow / dark / medium dull / grayish	
6	Yellow / very light / medium / yellow	*warm*

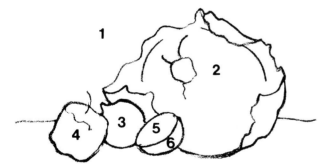

1	Yellow / dark / dull / greenish
2	Orange / dark / rich / orange
3	Yellow / light / medium / yellow
4	Green / medium / medium / yellowish
5	Red / light / bright / orangey
6	Orange / light /medium / yellowish
7	Yellow / light / dull / grayish

let's look at a lot of yellows in action

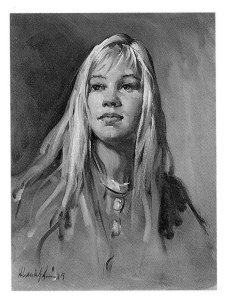

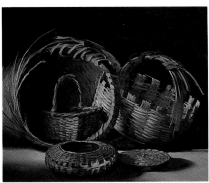

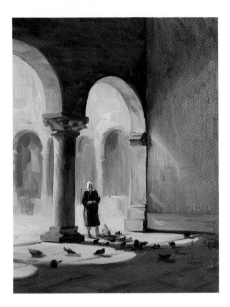

The **color band of yellows** (on the right) will help you understand the difference between tone and intensity. A to B shows yellow ranging from bright to dull with little change in tone. C to D shows yellow ranging from light and intense to dark and intense.

Melissa's hair (upper left) is yellow (Yellow Ochre and white, Cadmium Yellow Light and white). The background is yellow, too. On the left, it is dark and grayed, on the right, light and grayed (Burnt Umber into tones of black and white).

The **two bigger baskets (middle left)** are medium intensity, light yellows (Yellow Ochre, Cadmium Yellow Light and white). The **smaller baskets** are orangey-yellows (Yellow Ochre, Burnt Sienna and white).

The **soft yellow sunlight (lower left)** in the painting, "Feeding Pigeons" is a mixture of white, Cadmium Orange and Yellow Ochre.

yellows:

tones
intensities
hues

A C

B D

lesson #1
a practice lesson
in color mixing

Set up similar subjects in front of a dark background with strong lighting. Sketch in the composition with black paint greatly thinned with turpentine. Use a canvas no larger than 16 x 20, no smaller than 12 x 16. Do it boldly and use lots of paint. Starving a canvas of paint is starving a painting of color. Follow the numbers for a sensible order of application of your mixtures, that of from background to foreground.

Still Life with Lettuce

1 Background Burnt Sienna, white, black. Shadowed with Burnt Umber and Thalo Blue.

2 Lettuce White, Thalo Yellow Green (varied with more Thalo Yellow Green), Sap Green. Shadowed with Sap Green and gray (black and white). White membrane of the lettuce—white and Yellow Ochre.

3 Red onion Alizarin Crimson, Thalo Red Rose. Lighten with Alizarin Crimson, Grumbacher Red and white.

4 Pepper Sap Green, Thalo Yellow Green, black and white. Lighten with Thalo Yellow Green and white.

5 Lemon **Pulp:** Black, white, Raw Sienna, Cadmium Yellow Light. **Skin:** Cadmium Yellow Light and white.

6 Table White, a bit of black and Yellow Ochre.

Still Life with Asparagus

1 Background Black, white, Burnt Umber, Burnt Sienna

2 Wine jug Burnt Sienna, Alizarin Crimson. Shadow with Burnt Umber, Alizarin Crimson and Thalo Blue.

3 Pitcher White, a touch of black, Yellow Ochre.

4 Asparagus Sap Green, white and Yellow Ochre. Shadow with Sap Green and Alizarin Crimson.

5 Tomatoes Grumbacher Red, Cadmium Red Light and a bit of white. Shadow with Grumbacher Red, Alizarin Crimson and Sap Green.

6 Onion White, Burnt Sienna, Cadmium Orange. Shadow with Alizarin Crimson and Thalo Blue.

7 Table White, bit of black, Yellow Ochre and Sap Green.

3

THE USE OF WHITE IN COLOR MIXING

Many people come to the study of painting with misconceptions about color. What's more, they try to use these misconceptions to mix color. How I wish I could erase these distorted ideas, and have students use color as a practical way to record an artistic point of view.

The first thing I have to do is to clarify that the whites in nature are really *colored*, and that white paint is not a color. The seemingly light colored things that we paint, such as snow and white china, are always being influenced by a lighting condition that imposes a color upon them; whites, therefore, can be yellow whites or blue whites. No more can the term "off white" be used since "off" isn't a color. White paint is not white things. It is used in admixture with color to record the beauty of white things.

White is also used to lighten colors because lighter tones of colors are seen where subjects are in light. These areas are what I refer to as *body tones* and since most, if not all, body tone mixtures are lighted

areas of objects, white paint is the foundation of the mixtures.

You will not be able to appreciate the importance of white in color mixing without recognizing the basic character and importance of the body tone. Its *importance* is that it is one of the five tone values that makes things look real and round on the flat surface on which you paint. The body tone's *character* is such that it's where the light effects it directly; its color, as a result, has to be lightened with white.

White is also necessary in recording highlights, another tone value that bestows dimensional and textural effects to your painting. You can see now that white is important to the implementation of two of the five tone values.

The other three tone values — body shadow, cast shadow and reflection — also rely on the use of admixtures of white. I will discuss this use in subsequent chapters. For now, I want you to examine white in body tones and in highlights.

where there's light there's white

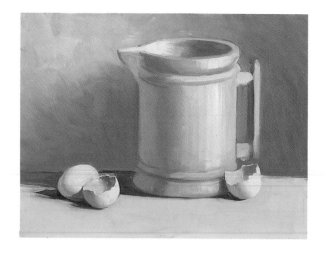

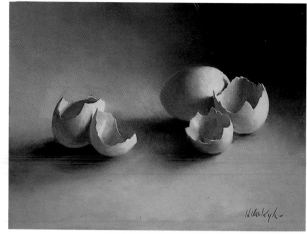

for white things

You can learn two valuable color lessons by painting a white subject: 1) most all body tones are made of colors mixed into white; 2) all white things are not pure white.

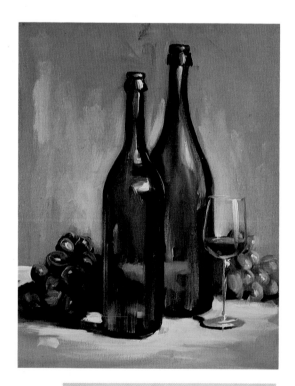

for highlights

Highlights on objects are not pure white either; they are white with a breath of the object's complementary color. Highlights on the green bottle: white and a little red; the amber (orange) bottle: white and a touch of blue.

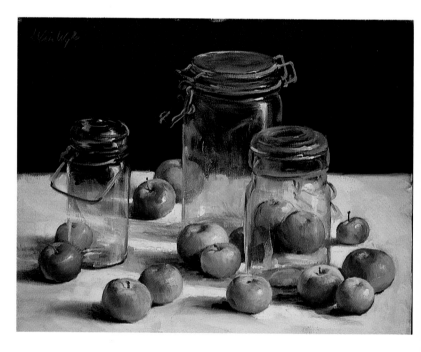

helpful hint

Don't make body tones so light that highlights won't show up.

flavor your color — warm or cool

Raw Sienna added into Alizarin Crimson and black and white

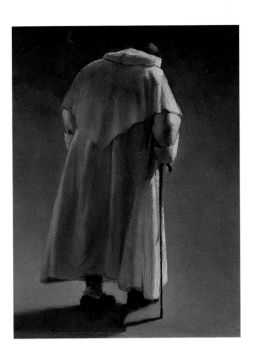

Raw Sienna, Alizarin Crimson into white

You don't have to use radically different colors to flavor your color presentations. Instead, infuse your reaction to warm and cool into your color mixtures. To illustrate, I wanted **warm tones of white** to portray the Roman monk's old, worn robe. On the other hand, I thought that Sheila's stylish dress should be **in cool tones of white.** The color swatch on the left of the monk shows the mixtures I used for his shadowed robe; on the right are mixtures for the lightened robe. The color swatch on the left of Sheila's portrait are the darker background tones of the portrait; the swatch on the right shows the mixtures of the light tones of her dress.

Burnt Umber into Thalo Blue and white

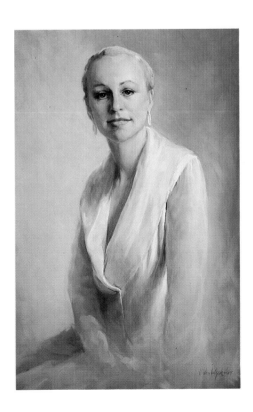

Yellow Ochre with Thalo Blue and white

lesson #2
painting better body tones

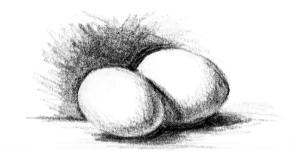

Project: Two eggs
Canvas size: 8 x 10
Painting time: Three hours

I've been asked why my objects look as though they "live" on my canvas instead of just painted on my canvas. You'll be able to make **your** subjects look forceful instead of weak, dimensional instead of flat, and brilliant instead of drab, by doing as I do. My secret is painting all body tones in twice, meaning in two coats of paint. My basic "two-coats" technique is massing in the body tone in a color mixture that is a bit darker and more colorful than my subject's actual color. After I have shaped it by its surroundings, I repaint it with a new mixture, one that is more like the subject's actual color. Sometimes, this is just lighter; and sometimes it's lighter **and** brighter. Practice my procedure by painting two eggs. Set them up, as shown, with lighting shining on them from the left.

1. Sketch them in with pencil just a bit larger than life size on your 8 x 10 canvas.

2. Fill in the entire canvas around the shape of the eggs with a medium-toned gray made of black, white and Burnt Umber.

3. With a darker tone of gray made of black, white, Burnt Umber and a touch of Thalo Blue, paint in the body shadows on the eggs and the cast shadows from them onto the background.

4. Fill in the remaining white canvas (which are the body tones of the eggs) with white, a little Burnt Umber, Cadmium Orange and a tiny, tiny bit of black. Blend this color into the shadow and paint it carefully up to the background gray.

5. Mix white, Yellow Ochre and a tiny bit of Burnt Umber and paint into the shapes of the body tones of the eggs again, but not right up to their shadows.

6. Finally, with white and a bit of Alizarin Crimson, lighten the body tone again, especially on the left as the shape touches the background.

This lesson is designed to just acquaint you with a technique that you should try to perfect with practice; use it when painting a body tone of any color. Now compare the two egg paintings on page 22. I did the one on the left in just twenty-five minutes, in front of three cameras for my TV show, hardly enough time for me to do the body tones in two coats. The egg painting on the right, however, enjoyed the luxury of more time, two coats, and quiet privacy.

4

THE COLOR OF SHADOWS

If you're like everyone else who paints, you want your pictures to record nature's character and beauty. To do so you must realize the difference between real and pictorial. I can still hear Rasko say to me, "Helen, you have the *audacity* to try to paint an illusion of a three-dimensional world onto a mere two-dimensional surface."

You can reconcile this difference by recording the five tone values that nature's light imposes on the things you see. What better way to learn how to record the depth dimension than to inspect how shadows can actually make a form look like it's jumping off a flat surface! Once you can see the two types of shadows — body shadows and cast shadows — you'll have to learn what colors you have to mix to make them look convincing.

How I wish that making the color of shadows was a simple formula! Generally, shadows can be made by mixing the object's color into a tone of gray (black and white) instead of into white, as is done when making the color of the body tone. Although this approach is correct, it's not complete enough to paint beautiful, convincing shadows. To paint both types of shadows (body and cast), you have to learn that they are made up of two parts: their edges and their interiors. The edge is the area where the shadow is somewhat colorless; the interior is somewhat colorful, depending on the surroundings and reflected light.

Inasmuch as there are two colorations, they have to be painted in two applications. The first one should be a color that's relatively complementary to the all-important body tone. Of course, this mixture has to be also darker in tone than the body tone. Very often, it is made by mixing the body tone's complement into black and white. For instance, the mixture for a shadow on yellow beach sand would be any violet into black and white. When a body tone is not a very light value with little white in it, such as in a red apple, the shadow mixture can be just green (Thalo Green or Sap Green) added to the body tone.

The more colorful quality of the interior of body and cast shadows can be made by mixing the object's actual color into the first shadow tone mixture. Therefore, in the beach sand mixture, Yellow Ochre and Raw Sienna are mixed into the black, white and violet mixture. *Never* use the body tone mixture in the shadows. It is too light due to all its white. In the case of the red apple, the color of the interior of the shadow could be Alizarin Crimson and Grumbacher Red.

The *reflection*, a tone value that's seen in body shadows, is very intriguing but dangerous. I call it the "shadow spoiler." In this chapter, I'm going to take the reflection away from you, just like taking candy from a child in order not to spoil his appetite. Later on, in this book, I'll give the reflection back to you.

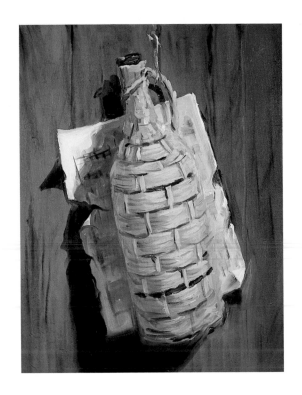

lesson #3

don't be afraid of the dark

Trompe l'oeil describes a special kind of dimensional effect. Instead of the subject being surrounded by space, the subject jumps out of space and looks as though it can be picked right off the canvas.

Doing a **trompe l'oeil** of something hanging against a wall singles out cast shadows and body shadows dramatically. Many objects can be used. Some suggestions: cooking ladles, an old hat, a fishing creel, or maybe an old violin. Of course, a successful **trompe l'oeil** effect is possible only when lighting imposes strong contrasts on the subject.

A good subject to paint as your introduction to **trompe l'oeil** effects: a wicker bottle hanging against a brown wall. I'm sure you can find one or two old Chianti bottles somewhere. Use the following procedure and color mixtures for the cast shadow on the wall and the body shadows on the bottle.

Step 1 Sketch the size and shape of the bottle with black thinned with turpentine on a 14 x 18 canvas.

Step 2 Mass in the entire background in a medium light value of black, white, Burnt Umber and Burnt Sienna.

Step 3 Mass in the green of the bottle with Sap Green and a touch of Thalo Green.

Step 4 Mass in the wicker of the bottle with Burnt Umber, Raw Sienna, Yellow Ochre and white. **Not too thick!**

Step 5 Now, paint into the background color the shape of the cast shadow from the bottle with a mixture of Burnt Umber, Alizarin Crimson and a bit of Thalo Blue. Paint the shadows of the strings and nail, even though they are not painted yet.

Step 6 With Burnt Umber and Burnt Sienna, paint into the interior of that cast shadow.

Step 7 Add lighter greens made of Sap Green and Thalo Yellow Green where you see light on the green bottle. Use Sap Green, Thalo Green and Alizarin Crimson for any darks. Add the shiny highlights with a lot of white and a touch of Alizarin Crimson.

Step 8 Shadowize the wickered part of the bottle with Raw Sienna darkened with some black and Alizarin Crimson. Use this mixture to suggest the weave or character of the wicker.

Step 9 Stroke a lighter tone of Raw Sienna, Yellow Ochre and white, into the body tone to suggest the wicker. Use even a lighter tone of Yellow Ochre and white where you see the lightest tones of wicker.

Step 10 With Burnt Sienna, Raw Sienna, black and white, paint in the wicker effect into the body shadow. For reflections, add some white and Yellow Ochre to the body shadow color.

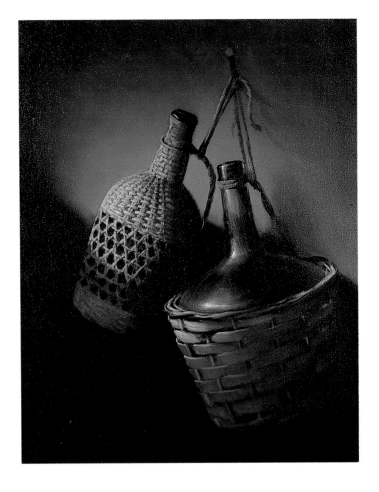

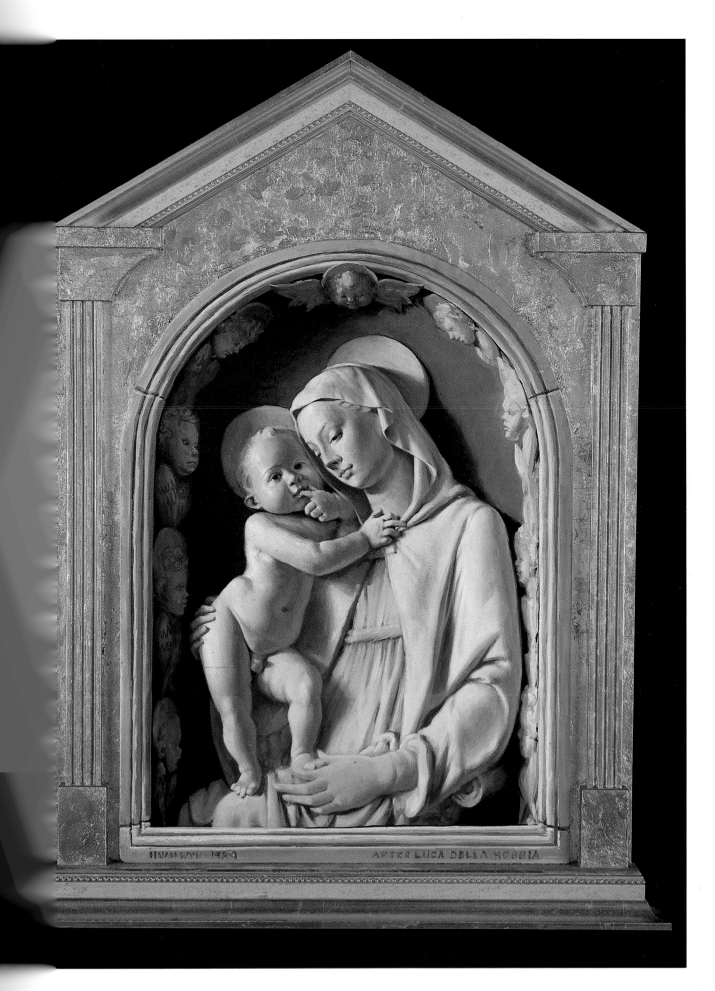

HUANNK 1989 AFTER LUCA DELLA ROBBIA

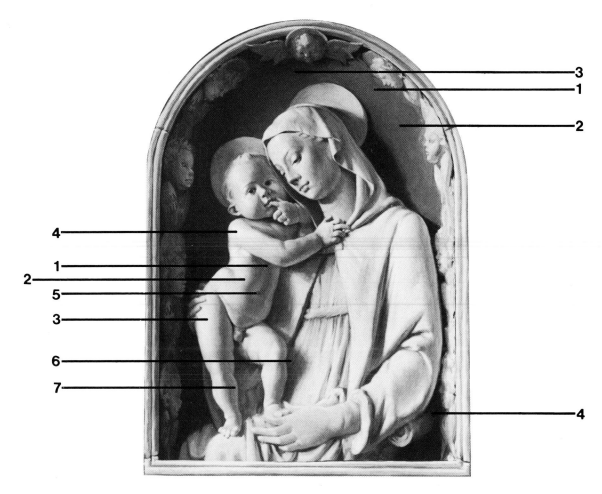

dimensional shaping with body shadows and cast shadows

At first glance, my painting of the della Robbia Madonna looks like a monochromatic rendering with the only display of color being the blue background. In actuality, the painting is in full color, as you will learn from the color mixtures of the five tone values. I've pointed them out and then listed them in order of application.

1. The body shadow on the Infant and His cast shadow combined: Black, white, Alizarin Crimson, Thalo Blue and a touch of Burnt Umber.
2. The first application of the body tone: White, Yellow Ochre, Burnt Sienna, Burnt Umber and Manganese Violet.
3. The second application of the body tone: White, Yellow Ochre and Burnt Umber.
4. The highlight on the body tone: White and Alizarin Crimson.
5. The interior of the body shadows: Black, white, Raw Sienna, Burnt Umber and Burnt Sienna.
6. The interior of the cast shadows: Black, white, Burnt Sienna and Burnt Umber.
7. The reflections in the body shadow: Black, white, Cadmium Orange and Raw Sienna.

The colors of the blue background:
1. Body tone (first application): Black, white, Thalo Blue and Burnt Umber.
2. Body tone (second application): Black, white, Thalo Blue.
3. Cast Shadow (first application): More Burnt Umber and blue into the body tone.
4. Cast Shadow (second application): A little Thalo Blue.

These mixtures model the entire statue even though they are pointed out only on the Infant and His cast shadow. The many places where the yellow body tone meets the violet body shadows are grayish in color because of the blending of a color and its complement. I call these edges "turning points"; they are often referred to as halftones. These gray edges, along with the grays that are caused by blending violet highlights into the yellow body tones, are very important to luminosity and dimension.

5

COLORLESS AND COLORFUL HIGHLIGHTS

Highlights, those shiny, little spots that contribute so much to a subject's texture and dimension, are seen where light strikes a shape so directly that the shape's color seems to disappear in glaring illumination. As a painter, you make your paint record what light is recording, and light *causes* those shiny spots. Making the color and tone of highlights is a major consideration.

Highlights are seen everywhere. The most obvious and stunning highlights are those seen on silver; more mellow ones are seen on polished wood. We polish copper to enhance its sharp, glowing highlight, while women dust their noses with face powder to actually reduce the highlight. In my book, *Welcome to My Studio*, I told the readers *where* highlights could be found (on the concave and convex planes that are in line with the light). Since *this* book is devoted to color and color mixing, the emphasis here, logically, is going to be on the *color* of highlights:

1. The very light spot type of highlights are always made of a lot of white with just a small dab of color.

2. The more mellow type of highlights are made of a light gray (black and white) with a dab of color.

Some highlights are in stark contrast to the color they are on, such as the ones on glass; others seem to blend into the colors they are on, such as on dull pewter, cheeks and powdered noses.

No matter what type of highlight you want to paint, it should be made of a color that is relatively complementary to the color it is on. Consequently, green bottles have red highlights, brown wood (a form of orange) has blue highlights, blonde hair has violet highlights. Mind you, these highlight colors I have just cited are not as obvious as the red of a rose, the blue of a sky, or the violet of a lilac. They are very slightly colored, and are the object's lightest tone value.

A properly colored highlight imparts the beautiful glow that light imposes on color. If you don't use the complement of the subject in your highlight color, the color of your subject will look unreal and raw. The most common color mistake in painting highlights is to just use a lighter version of the object's color, such as a very, very light green on a dark green bottle. NO! NO! NO! If you study a highlight very carefully, you have to come to the conclusion that it could *never* be made of the same color it is on and show up as dramatically as you see it. By using a tone of a color's complement for highlights, you balance the temperature of your color presentation, which is necessary for getting natural-looking color. Cool gray-blue highlights on warm brown-colored hair will make the hair look naturally shiny. On the other hand, lighter tones of brown for highlights wouldn't.

I'd like to point out that highlighting a color with its complement is not an iron-clad rule. There are cases when highlights are *not* completely complementary to the colors they are on. Instead, they are relatively cooler or warmer in temperature to the colors they are on. Orange copper (the warmest color) has a pink highlight (pink is a cooler color than orange). Brass can have greenish yellow highlights (cool) on its slightly orangey-yellow (warm) basic brass color. Warm and cool colors are relatively complementary to each other. Highlights on flesh are also examples of ones that are just relatively complementary.

You can now see how important it is to always define the color of a subject as one of the six colors so that you will know what color to make its highlight. Therefore, a white vase has to be defined as some kind of colored white, a yellow, for instance, so violet can be used to make it look shiny. So-called black things also have highlights. Black hair is actually a very dark orange (a mixture of Burnt Umber and Alizarin Crimson into a dark gray of black and white). Its highlight would be orange's complement, a gray blue, made of black, white and blue.

Since metals are "shining examples" of highlights, they are the subject of this chapter.

the colorful metals

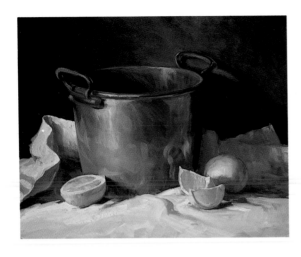

Cadmium Red Light and white on Burnt Sienna, Cadmium Red Light and white

The tone of a highlight color must be in strong contrast to the tones that it is on. Never mistake copper's basic color to be the light tone of its highlight.

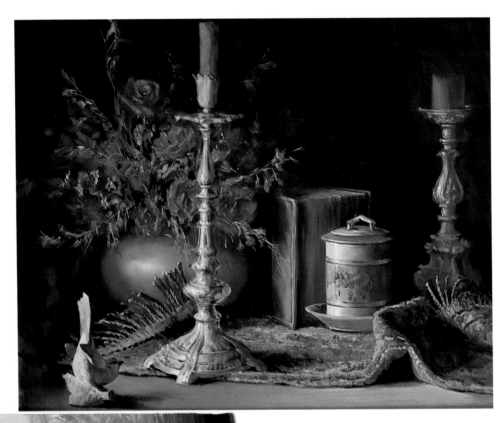

Cadmium Yellow Light and white on Cadmium Yellow Medium and Burnt Umber

One light source causes one highlight to appear on **each concave and convex shape** of a metal object. The large candlestick has 28 shapes and 28 highlights.

the colorless metals

Burnt Umber

Black

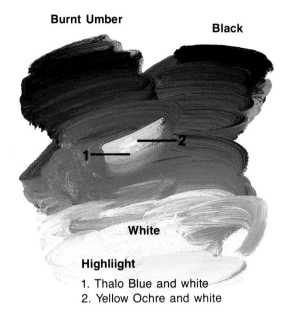

White

Highliight

1. Thalo Blue and white
2. Yellow Ochre and white

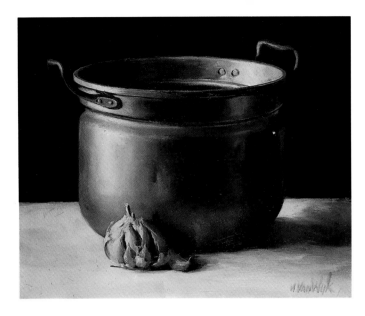

Highlighting a color can be done in three ways:

1. Piled on top of the body color.

2. Embedded into the body color.

3. Piled on in a somewhat large area and then cut down with the body color.

The procedure is determined by the type of highlight: little and sharp; fused in; or sharp with fused edges.

The highlights on these old cooking pots were embedded into the basic colors and then accented with a light tone. The aluminum pot belonged to my mother-in-law; I use if for soup. I suppose the iron pots were also used for soup, but they are before my time.

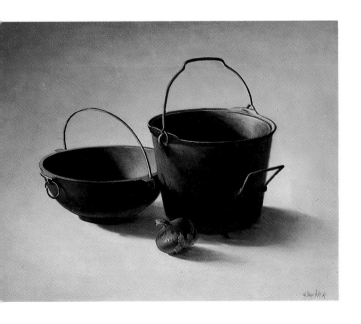

Burnt Sienna

Burnt Umber and Black

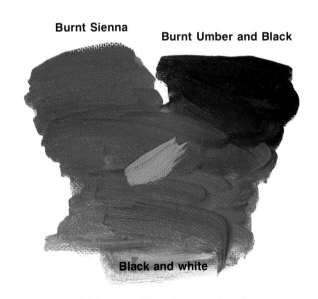

Black and white

Highlight — Thalo Blue and White

color mixtures for metals

	Copper	Brass	Pewter	Silver	Iron
Body Tone	Burnt Sienna Cadmium Red Light, bit of black & white	Burnt Umber, Cadmium Yellow Medium	Black & white Burnt Umber	Black & white, Raw Sienna	Black & white Burnt Sienna
Body Shadow	Burnt Sienna Alizarin Crimson, Thalo Blue	Thalo Blue & Alizarin Crimson into body tone	Add more Burnt Umber, Burnt Sienna, Alizarin Crimson & Thalo Blue,	Add black, Alizarin Crimson & Thalo Blue to body tone mixture	Thalo Blue, Burnt Sienna, Burnt Umber
Highlight	White, Cadmium Red Light, Cadmium Orange	Cadmium Yellow Light & Medium into white & even lighter with Cadmium Yellow Light & white	White & Thalo Blue. Lighter with white & Yellow Ochre	White, Alizarin Crimson & Thalo Blue. Lighter with white, Yellow Ochre.	Black & white & Thalo Blue
Darker Reflections	Burnt Sienna, Burnt Umber	Alizarin Crimson & black	Burnt Umber	Burnt Umber	No reflections. Thalo Blue & Alizarin Crimson for darkened darks
Light Reflections	Cadmium Red Light & light gray (black & white)	Cadmium Yellow Medium	Colors that reflect into it mixed into gray (black & white)	Depends on colors surrounding silver	Gray-blue, the color that is influencing the iron
Cast Shadows	Cast shadows are complementary mixtures to the colors they are casted upon. Copper things don't cast blue shadows. A cast shadow from a copper pot on a yellowish-white cloth is violet. A cast shadow on copper from a lemon is bluish because the cast shadow is on the copper color.				

6

THE COLORS OF FLESH

There is a large group of people who reserve a special kind of awe for portrait painters, holding them in far more esteem than they do for painters of pots, vases, fields and streams. Probably responsible for the elevation of portrait painters to this niche on Mount Olympus is the mystery of capturing a likeness, making mere paint record skin that looks alive, depicting eyes that follow the viewer all around the room, and portraying mouths that might even speak.

Many students think the difficulty of portrait painting is in mixing flesh colors. Actually, flesh colors are quite easy to mix. Basically, they are yellows, oranges and reds mixed into white or into gray. You'll find many yellows, oranges and reds in paint: all the Cadmium colors and all the earth colors, ranging from bright to dull, from light to dark. All *you* have to do is look at the model's skin and match it. But, Ho! Ho! Ho!, there is much more than the flesh color to consider. You have to be aware of other factors to orchestrate in order to paint a portrait and get a likeness, such as:

1. The placement and size of the head.

2. The proportions of the features of the face: the forehead, eyes, cheeks, nose, mouth, chin. All have

to be observed and carefully painted in proper proportion to each other.

3. The perspective at which you look at the features.

4. The choice of the tone and color of the background that will be suitable to the model's hair, skin and manner.

5. The correct shape of the contrasting tones of the flesh colors.

6. The coverage and character of the paint on the canvas.

All these elements have to be executed with color mixtures. So even though flesh colors are easy to mix, flesh colors in action are difficult. There is still another difficulty that is only peculiar to portrait painting. Portraiture is a joint effort. You need your model's patient, endorsing cooperation.

This chapter concentrates only on the colors of flesh not on the art of portrait painting. That's a book of its own! No matter *how* many books you read on painting, none of them can substitute for hours and hours of practice. Books can, however, direct you to practice the right way. It takes just as long to paint badly as it does to paint well.

every flesh color is different

Light Red

Raw Sienna

White

Burnt Umber

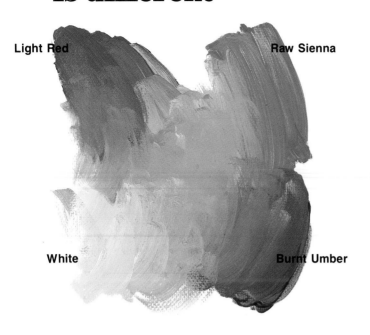

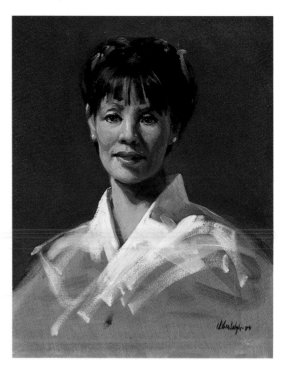

Slight variations in color mixtures will breath some life into flesh colors. In the color swatches you can see how the colors and white are moved together rather than mixed completely. Don't mix up one big puddle of one flesh color and especially don't do it with a palette knife. Overmixing deadens a color; whereas colors that are quickly eased together on a palette will radiate with vitality on the canvas. This is why you should use a soft, malleable type of white paint not a thick, heavy one.

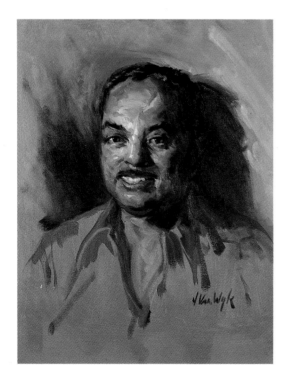

all flesh is color into white

Burnt Umber

Burnt Sienna

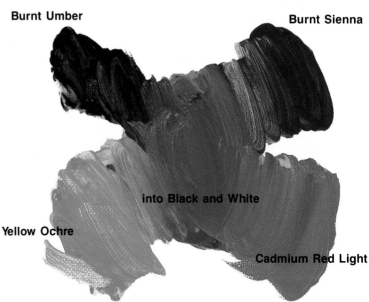

into Black and White

Yellow Ochre

Cadmium Red Light

flesh in light flesh in shade

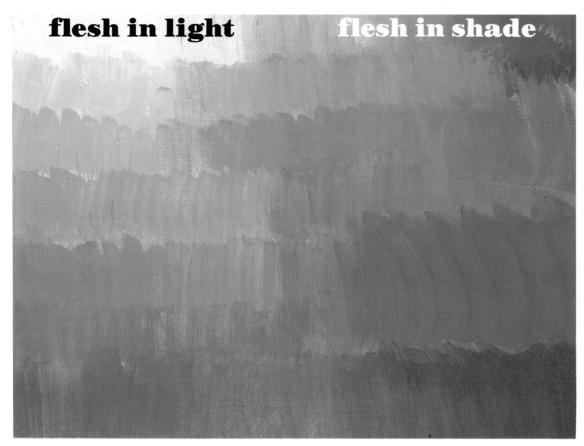

The light flesh mixtures are yellows and reds mixed into white. The shaded tones are the same yellows and reds mixed into gray.

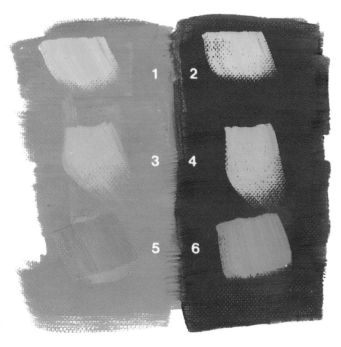

See how the different background tones can change the appearance of the very same flesh mixture. Yes, it's hard to believe that 1 and 2 are the same flesh mixtures, as are 3 and 4, 5 and 6.

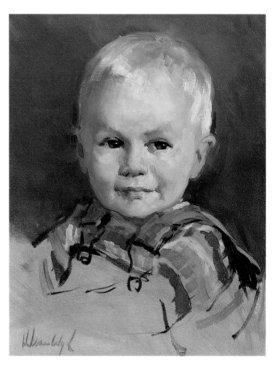

Don't overwork flesh mixtures, especially when painting children. Try to be accurate with shapes and colors per stroke.

lesson #4

possible flesh mixtures
for the 5 basic tones

1. **Body tone.** Move a big gob (teaspoon) of white into a mixing area of the palette. Into a corner of it add Yellow Ochre and some Cadmium Red Light. Move more bright yellows and bright red, as needed, or duller warm colors, such as Burnt Umber, Burnt Sienna into the puddle. Don't be afraid to make this mixture colorful. The first application of the body tone should be strong enough in coloration to withstand a subsequent lightening (you learned this in Lesson #2). Your paint mixture shouldn't be thin and runny. You'll know it's a good consistency if you can't see the color of your palette through it. This mixture can be spread on the canvas by the dampness of your brush.

2. **Body shadow.** Near the flesh puddle on your palette, mix some Sap Green, black and Alizarin Crimson in a dark tone that contrasts the tone of the flesh mixture.

3. **Cast shadows.** Darken the body shadow mixture with Burnt Sienna and a touch of Thalo Blue.

4. **Lighter body tones.** Into a new gob of white add amounts of warm color, such as Cadmium Yellow Light, Cadmium Orange, Cadmium Red Light.

5. **Highlight.** Add a little Cadmium Yellow Medium and Alizarin Crimson to white making a very light tint. Work this mixture into the flesh on the planes of the face that seem to shine.

6. **Color in the shadows.** Into the shadow mixture add a touch of white, Raw Sienna and Light Red.

7. **Reflections.** Add a touch more white into the color-into-shadow mixture plus any color that seems to be influencing or reflecting into the shadow.

8. **The darkest dark.** Mix Burnt Umber, Alizarin Crimson and a touch of Thalo Blue into a corner of the shadow mixture for nostrils, corners of the mouth and shadows on the eyes from ther upper lids.

 These mixtures are merely a guide, not guaranteed to record person's flesh colors. People's skin not only vary in color but in texture as well. Add to these variations different lightings, such as soft, flattering, strong, or harsh. Don't be tempted to paint babies from photographs; their skin is too delicate and their likenesses too fragile. This kind of challenge is too hard to meet without some experience gained from working on more substantial models.

7

PORTRAITURE – PATIENCE AND PRACTICE

Benjamin West (1730-1813) was a contemporary of the great English portrait painters, Sir Joshua Reynolds, George Romney and Thomas Gainsborough. And Gilbert Stuart, certainly the best known portrait painter in this country, studied with West in England before both of them came to the American Colonies.

A few years ago, the National Portrait Gallery in Washington, D.C., mounted an exhibition of the paintings of the students of Benjamin West. Each student was represented by a self portrait. I could only speculate that a self portrait must have been an assignment by West to each student since I, too, have often assigned my students to do the same. The self portraits made the exhibition particularly fascinating to me. They also validated my opinion that a self portrait is an excellent example of an artist's painting technique. The boldly interpreted likeness in each painting jumped off the canvas in strong, simple patterns of light and dark, unaffected by any social influence or pressure of commission. Having painted myself many times, I identified with the expressions on their faces, expressions of concentration; ones that are hardly ever worn in public. Even people who pose for me don't see the expression that appears in my self portrait. During a sitting, I try to put my model at ease, something I don't have to do when painting myself. I try to draw out my model's expressions and personality; I don't have to do that to myself either. I make my model look at me so his eyes will look *out* from the canvas with an expression that everyone will recognize. The eyes of a self portrait, however, tend to look off a canvas with introspection.

Students of portraiture need hours and hours of working from models to practice color mixing of the many tones of flesh in light and shade and to develop confidence that they can interpret the basic features of the face correctly. Human features are all structurally the same; likenesses are just versions of the same basic shapes. With this in mind, why not, then, study the basic shape by practicing on yourself?

I've included this chapter in an effort to urge you to practice not only portraiture by using yourself as a model but to just *practice painting pictures*. Instead of painting portraits of your grandchildren, or a picture to fill the space above the sofa, paint to merely experience the challenge that any subject presents. *Paint to learn to paint better.* It's no secret that pianists practice all the time, as do ballerinas, and actors rehearse constantly. Why shouldn't would-be painters practice and rehearse instead of always painting pictures that are going to be on stage in frames?

I've been practicing all my life, not only when I do a self portrait, but whenever I'm in front of my easel. I always concentrate on what I'm doing, not concerned with, nor inhibited by, the quality of the outcome. My paintings are examples of the very best I can do. If you'll approach painting with the same attitude, your pictures will have originality and will be truly your artistic endeavors. I know, and you will be surprised to discover, how much better your paintings will be.

a close look at eyes

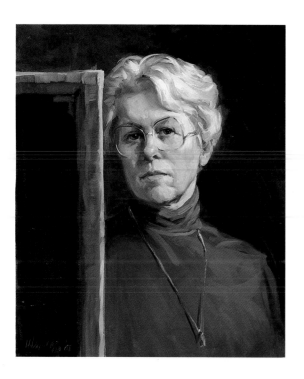

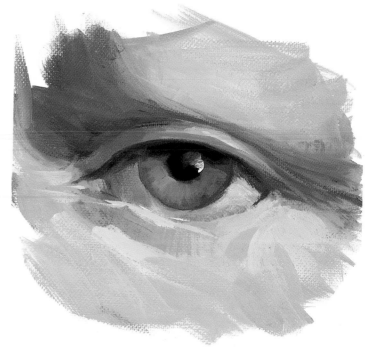

The whites of the eyes are not white. Even the highlights in eyes are not white. The whites of eyes are the model's basic flesh color lighted a bit with a gray made of black and white. The highlight is a very light, warm gray (black, white, Yellow Ochre). I used the same lighting for both these portraits. Notice how a similar shadow pattern falls on our features, describing our likenesses. The detail of the eyes shows how simple light and dark shapes combine to form the most complicated feature of the face.

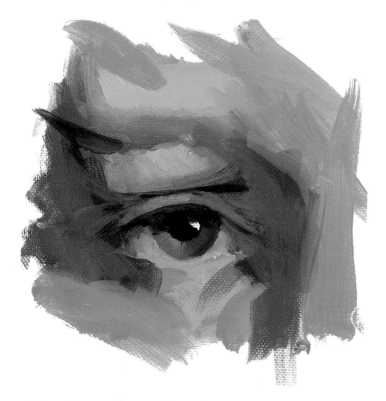

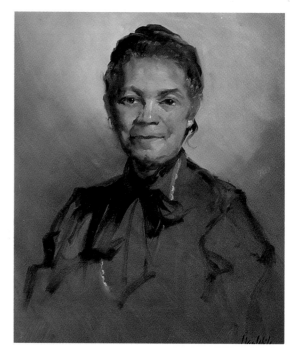

look for lighting instead of likeness

I painted this self portrait back in 1961, when I was young (I wonder if I really looked that innocent). The painting makes me appear to be right-handed since I'm holding my palette in my left hand. Those who have seen my TV show know that I'm left-handed. Because I look at myself in a mirror to do a self portrait, I see my reflection in reverse. I painted this self portrait in a studio lighting condition used so often by portrait painters. I've seen it in paintings by Rembrandt, Rubens, Hals and David, to name a few. My light body tone is shaped by the dark background on my left. The shadowed part of my body is shaped on the right by the lighter background tone. My cast shadow falls over my palette and onto the background. This is a humanized rendition of the basic values illustrated on page 60.

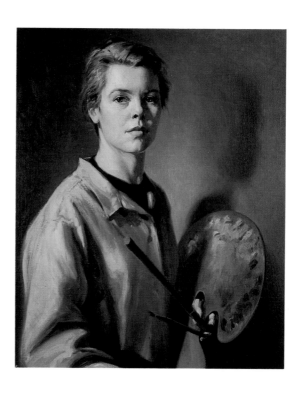

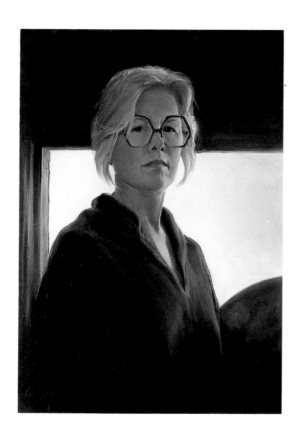

I painted this self portrait in 1985. Older, of course, I disguised my age by putting my face all in shadow. It wasn't vanity that made me use this lighting; it was provoked by a conversation I had with a man who was posing for his portrait. I explained to him that I was looking at the lighting on his face, and asked him whether he could see any lights and darks on my face. "No," he said, "your face is entirely in shadow." After he had left, I was curious about what he had said. Using a mirror to see what he had seen, I found the lighting to be so intriguing that I set up a canvas. The white of the bare canvas reflected into the right side of my shadowed face making the lighting effect even more interesting.

i'm beginning to see the light

By now, you may be tired of my constant reference to an object's **color being in light and shade.** I must emphasize and impress upon you that it is the light you see on a subject's color not its very own color. I hope these "odd couples" (pairs of totally unrelated objects) will help you come to the conclusion that "I'm beginning to see the light and the dark":

Color Mixtures for	their colors	in light	in shade
Dirt roads Dirty blondes	Yellow Ochre, Burnt Sienna, Burnt Umber	Into white	Into black, white, Alizarin Crimson
Red lips Old red barns	Cadmium Red Light, Light Red	Into white	Into Sap Green and Alizarin Crimson
Teeth Gray hair	Raw Umber	Into light gray of black and white	Into Thalo Blue and Alizarin Crimson
Mahogany tables Brunettes	Alizarin Crimson, Burnt Umber, Burnt Sienna	Into light gray of black and white	Into Thalo Blue
Green grapes Sunlit grass	Thalo Yellow Green, Raw Sienna	Into white	Into Manganese Violet
Pewter Fog	Thalo Blue, Burnt Sienna	Into light gray	Into dark gray of black and white
Lemons Daffodils	Cadmium Yellow Light, Yellow Ochre	Into white	Into Manganese Violet

The fact that these odd couples' color mixtures could be the same may lessen your anxiety about getting the right color of your subjects, thus freeing your attention to focus more on an object's shape.

8

COLOR AND THE FOCAL POINT

A focal point is the sum and substance of pictorial composition; it is often referred to as the *center of interest*. Before examining how color serves as a focal point, there are some elementary factors about this area of your picture that I should restate. They are:

1. The focal point should never be in the middle of your canvas.

2. There should only be one focal point per picture.

By realizing the importance of the focal point, you should make all the colors of its surroundings respect its importance. I like to refer to the focal point and its surrounding areas as positive and negative space. These designations make me consider the focal area as a place for positive colors, positive shapes, positive contrasts in relation to the supportive — less dominant — colors, tones and shapes of the focal area's surroundings. It's elementary that in order to make your color mixtures of the negative space supportive, the positive colors of the focal area have to be established first. I'm not saying that it's the very first thing done on the canvas. Most often, after the composition is set down, a background of tone and color has to be painted in so can then start to paint the focal area in shape, tone and color. The positive and negative spaces are like balancing a see-saw, you work on one area, then the other. It's this thinking that directs your color mixtures to tip the power of your color on the focal point side.

Oddly enough, the areas of the canvas that can serve the focal point well are its four edges. That's where the picture's interest comes to a complete halt. Take care how shapes, tones and colors meet the edges: fuse the colors, darken the tones and *never* let shape just touch the edges. Once you realize the radical differences of these two areas, you will relegate the area between them as intermediate in interest, and you should paint it accordingly.

It's impossible to give you definite instruction about colors in the focal point. All I can do is caution you to always have the focal point uppermost in your mind during your picture's development. The attention and concentration that's needed to paint the entire area of your canvas can mislead you into using colors and tones that, in their final appearance, do not benefit the overall presentation of the subject. A way to notice if this is happening is to step back so you can view your work from a distance. It's the best way to see if the focal area's importance is being invaded by distracting elements.

In this chapter I explain how I deal with the focal areas in my paintings. I hope it will give you some insight about pictorial dramatics.

don't center your interest

single out a shape

This painting, done on my TV show, reveals the simplest way to establish a focal point. Interest is focused on the cylindrically shaped pewter tankard by the many cube-shaped books. The tankard's gray color is singled out by the colorful red book behind it.

Helpful hint: Contrast colorless with colorful. Colors on color fight for attention and are not that easy to paint.

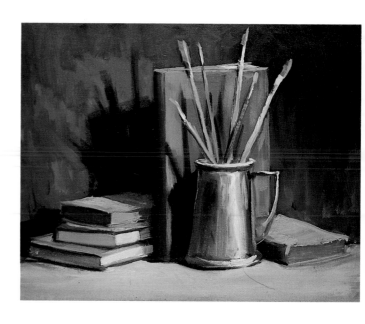

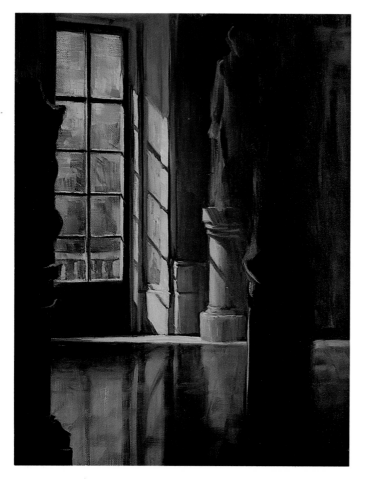

Like bugs seduced by a lamp in the summer night, we too are attracted to the light. At least, I know that I am. While visiting the Capitoline Museum in Rome, the light from a window shining on the wall and marble floor caught my eye. I located the light patterns surrounded by dark in the left lower area of my canvas. The look of the shiny floor has provoked interest and the question, "How did you paint it?" I painted the tones of light reflecting on the floor in downward strokes and left them to dry. Then, I applied a gray greatly thinned with medium over this area which semi-obscured the reflections, giving the area a feeling of a surface.

single out a contrast

find a center of interest

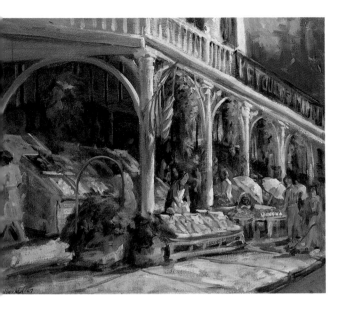

focus on a thing

The thing about **Ketchopulos Market** that fascinated me was the pole in the foreground with its flag, surrounded by an abundance of produce. I painted this area more carefully than its surroundings. Even though you are aware of the entire building, your attention is arrested by the focused area. Emphasize the thing that attracted your attention with paint. Don't distract your viewer's attention from it by too much detail and contrast in the outlying areas.

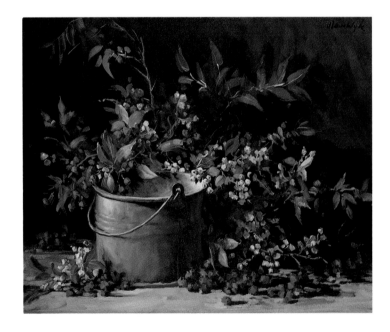

The painting of an old pail and blueberries is an example of how a focal point does not necessarily have to be an object. In this painting, the focal point is the area where the berries hang over the back of the pail. Interest is very much localized in this area by the bright colors of the leaves and berries and the light on the pail.

focus on an area

helpful hint

In critique classes I found more paintings suffer from a lack of a focal point than from a lack of good drawing. Is it because importance is paid to drawing thus the significance of a focal point is overlooked? I think so. It's ironic, because drawing should serve to delineate a focal point, not ignore it. Finding and painting an effective focal point is relatively easy. All you have to do is look out of your window, or into a room, focus on something that interests you, and *viola! — there's your focal point!* The area surrounding this center of interest is seen with your peripheral vision. Now, reduce this entire visual experience to a canvas, and make sure you put your point of focus off center.

lesson #5
maintaining the focal point with painting procedures

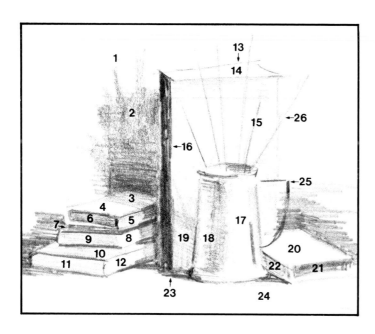

1 A forceful, well-placed focal point can hardly be obscured by the basic, sensible procedure of starting with that which is farthest back and, one by one, painting things as they near you, ending up with the foreground. I've numbered each element of the book-and-tankard composition to show you my progression of application. A final finishing stage of accenting the focal area with lights and darks is always helpful.

2 I've numbered the elements of the blueberry painting to show you that I use a procedure for compositions with more subtle focal points. After planning out the entire composition on a toned canvas, I actually start painting the focal area. My progression of application evolves from it.

The way that you attack your canvas with paint always should include respect for the importance of the focal point.

9

THE AREA THAT SURROUNDS THE FOCAL POINT

I spend much more painting time working on the surroundings of my subject and the negative space than on the actual subjects. It's very subtle work to paint in areas that in their final appearance are wonderfully unnoticed. I work to make these areas be an asset to the appearance of the subject and to create a form of pictorial atmosphere.

The look of my paintings results from the way I look at my subjects. When I'm faced with a subject, I see it and — don't laugh — I see the air around the subject, too. Yes, I pretend that the air is a substance. In a way, it is. Don't movements in air create breezes that can be felt? This air of mine is in the shape of a box. Its outer dimension in height and width corresponds to the proportion of my canvas. Its depth dimension extends from my place at my easel to the space that is behind my subject — or the so-called background. Within this box of air is a focal point and its supportive surrounding areas. Seeing my composition as if it were in a box of air helps me to orchestrate all of my colors instead of merely painting them in as isolated elements. I try to include air in my color mixtures, and imagining that I see it helps me to do so. By inviting you to share with me my "box of air," I may not give you any instruction about actual color mixtures, but I hope it will explain how I judge colors as I mix them. If one of my mixtures looks completely unrelated to a quality that I think I've imparted to other mixtures, I'll change it to make it fit in.

The many mixtures I have to judge fall into two categories: those that record the subjects; those that record the spaces around them. The mixtures of the colors of the subjects are the easier ones because I have the actual colors to refer to. Their surroundings pose more difficulty, and it is in mixing them that I rely on my "box of air" effect.

The colors in the focal area are the least affected by this air. They are sharply painting and clearly recorded. As I work on areas that move toward the outer dimensions of the canvas, I diffuse the edges of shapes, I reduce the intensity of colors, I see less detail, in effect, I respond with my paint to the overall concept I have of my subject. Paintings that don't look "real" are ones that look as flat as the canvases they are on. As soon as a painting looks three dimensional, in that the composition appears to enjoy being in an atmospheric box of space, we accept it as being *realistic looking.*

atmosphere . . .

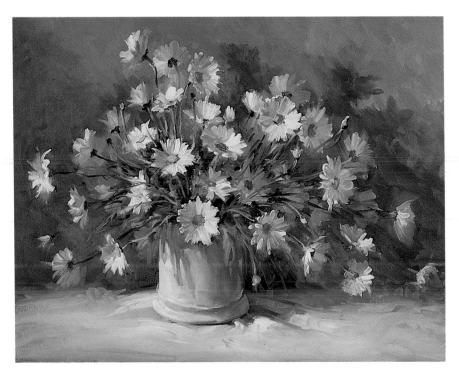

I initially invest atmosphere into my color mixtures by not painting any of the dark tones as dark as they are, and not recording the light tones as light as they are. I save the actual tones of light and dark to accent the area I want to come out in sharper focus. I repaint some of the already light areas with even lighter light mixtures, such as on the daisies located above the vase, on the vase itself and on the table around the vase. Doing so relegates the initial mixtures used on daises, vase and table to be atmospheric.

A gradation of color from light near the subject to dark and grayed near the canvas edges is another way to implant a subject in atmosphere with paint.

... and space

All the fruit in this painting appears more up front without much atmospheric influence because I added lighter, crisper colors on the positive area of the composition which extended quite near to the side edges of the canvas. The feeling of depth in this picture adds the atmosphere and is due to the fact that all the subjects overlap each other, from the watermelon slice to the front folds of the cloth.

The composition of grapes as a subject is unlike the watermelon painting because I made the light shining on my "box of air" focus not on the subject but on the area surrounding the grapes and leaves.

In all four paintings, the focal area is just off center. In the flower paintings, the upper left; in the fruit ones, the lower left.

...and now the subject

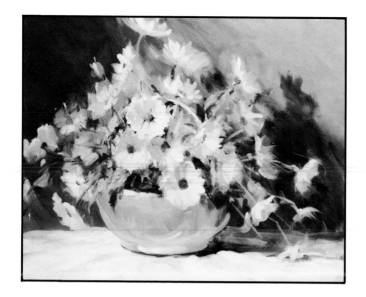

This black-and-white reproduction of the daisy painting I did on TV points out dimension, solidity, atmosphere and unity of composition. Yes, all of these things can be painted into your pictures once you think of the composition of any subject as a large ball-like shape that has to situate itself nicely on canvas.

The circle superimposed on the composition of the daisies illustrates the solidity of the entire bouquet. The remaining canvas surrounding the circle is its atmosphere. The cast shadows on the right of the background from the flowers is where the ball would have casted a shadow. The lightest flower, the focal point of the painting, is where the highlight would be on the ball.

The spiraling line that starts at the focal area illustrates how the presence of light becomes the presence of interest in a painting.

10
LIGHT BACKGROUNDS

Colors of subjects are greatly influenced by the tone and color that surround them.

Colors react to their surroundings on canvas. Since colors are mixed and judged on your palette before joining those already on your canvas, the color of your palette should be taken into consideration. A white palette makes mixtures look dark; a black palette would make all mixtures look light. Because of this, I have to warn you against the white peel-off paper palette pads that are so widely used today. It's true that it's easier to "throw a palette out" rather than having to clean one, but in the end it turns out to be too costly. Not only are you putting yourself at a color-mixing disadvantage, but you're wasting expensive paint as well.

I find the medium-warm tone of my wooden palette most accommodating to any color mixing. My second choice for a palette would be one that is a middle tone of gray.

On the rarest occasions, I will use a very light background, which makes the subjects' colors dark by contrast. Since my subjects are the centers of interest and we are more attracted to light than dark, I prefer a background that makes my subject's color *lighter* by contrast. Light backgrounds seem to add a decorative quality to painting, and should be used for that purpose.

light backgrounds darken subjects

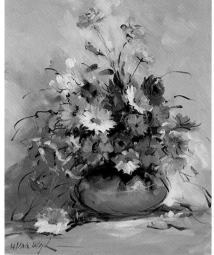

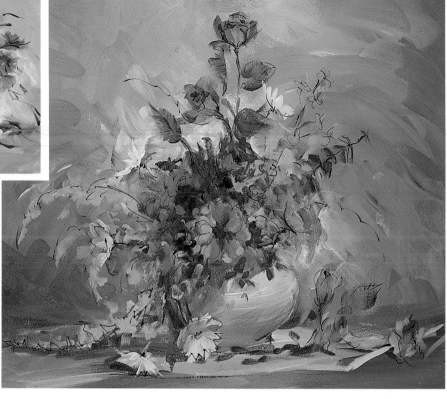

The black accents, that I call calligraphy, were done last with Ivory Black, greatly thinned with turpentine and linseed oil (half and half), capriciously drawn over the color with a small round brush (rigger type).

The violet color looks different against light and dark backgrounds. Color mixtures always have to relate to the tone of the background.

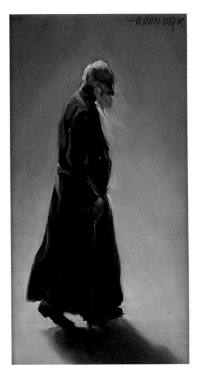

dark subjects need light backgrounds

Dark subjects look best sihouetted against light backgrounds. Their shapes can be nicely rendered by painting the background color into the subject's shape and then moving the color of the subject back out into the background color either sharply delineated or blended. These found-and-lost edges contribute greatly to recording the subject's dimension.

Just as white things are not white paint, black things are not black paint. I made the black of both the monk and the dog orange (black, white and Burnt Sienna) with blue-blackish shadows and gray-blue highlights.

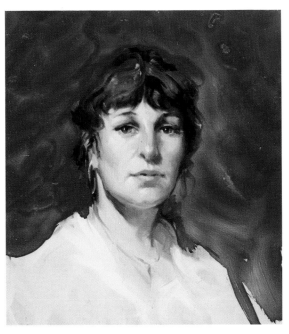

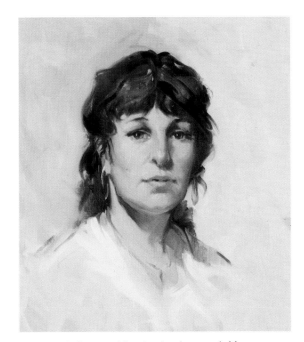

The entire color presentation of your subject, in this case skin color, is influenced by the background. You can see how changing the background on Linda's portrait from light to dark has also changed her flesh color.

Helpful hint: This factor can be used as a corrective measure: lighten a subject's colors by darkening the background or darken them by lightening the background.

lesson #6

Project: Paint flowers against a light background.
Canvas size: 16 x 20 canvas.
Painting time: Approximately four hours.

You've learned that light backgrounds make colors look dark by contrast. Even a color as light as Cadmium Yellow Light will look dark on a background made of white and a touch of Alizarin Crimson. This can be an advantage in painting the vibrant colors of flowers, especially violet ones. The tubed bright colors, such as the Cadmium Yellows, Cadmium Orange, Cadmium Red Light and all the violets and blues are most vibrant as they come from the tube. Adding quite a bit of white does lighten them but it also dulls their intensity; working with these colors with just small amounts of white is easier.

The following procedure is for painting any type of flower against a light background: red roses, poinsettias, zinnias, pink petunias, geraniums and lilacs, to name a few.

1. Wash a white canvas with turpentine (makes it easy to wipe off mistakes in drawing with a turpentine-soaked rag).

2. With lots of turpentine and a little black paint sketch in the placement of the entire flower arrangement, making it fit nicely on the canvas (don't use any of the colors; they are harder to work on and not as easy to erase).

3. Draw the flowers using simple shapes: circles for the ones facing you; ovals for the other ones.

4. Mass in the color of the most important flower; it should be within the overall bouquet's shape—not in the middle and in its color: a red petunia would be Grumbacher Red; a pink geranium, would be Cadmium Red light, Thalo Red Rose and a touch of white.

5. Paint the greenery, if any, around it in Sap Green, black, white and Thalo Yellow Green.

6. Mass in the general color and shape of all the flowers. Mass in the ones that are against the background smaller than they really are so that you will be able to paint the background behind them.

7. Paint the background in a very light mixture: white, Yellow Ochre and a very small amount of Manganese Violet.

8. Paint the vase.

9. Paint the foreground.

10. Paint the flower shapes and the leaves out over the background color.

11. The entire painting process up to this point should be done with paint thick enough to cover the canvas well.

This is the time to step back to see how your picture looks. Ask yourself: How's the composition? Are the colors clean? Is the paint thick enough? Do I like what I see?

Your answers should tell you that perhaps this stage looks too posterlike and you'll want to adjust it by "mushing" some colors together. The flower shapes might have to be restated. With black, white, Raw Sienna and Manganese Violet you could suggest a cast shadow on the background.

NOW THE FUN STARTS.

12. By adding some white into each flower color, stroke in the lighter tones you see that form the petals.

13. By adding a touch of Sap Green and Manganese Violet to each flower color, add any shadows you see on the flowers.

14. With white and a breath of Alizarin Crimson, lighten the background near the bouquet.

15. With Thalo Yellow Green and white add light to the greenery; with Sap Green, Thalo Green and a touch of Alizarin Crimson add darks to the greenery.

16. Accent the foreground near the vase.

17. Sign it! Sell it!

You realize, of course, that you have to have the subject in front of you to refer to and as an inspiration. Any time you work from your own subjects, even if you are guided by an illustration, your painting is a personal, original presentation. Why? Because your endeavor was one you and no one else ever experienced before.

11

MEDIUM TO DARK BACKGROUNDS

The easiest background tone to use is one that is darker in tone than the light tones of the subject but lighter than the dark tones of the subject. A lot of the time, I use a medium-toned background, particularly on portraits.

I often do resort to dark backgrounds for dramatic presentations. If there is such a thing as easy color mixing it happens when colors are related to a dark background. The color mixing condition that seems to plague beginners, that of chalky color, doesn't seem to rear its ugly head when they work with a dark background. Small amounts of white will lighten colors of subjects enough to make them show up against a very dark tone. I hate to introduce into this discussion the awful paintings that have been done on black velvet (at least, all of the ones that I have seen have been awful). I bring them up only as an example of how colors do show up vividly on very dark tones.

I use a dark background when it occupies a small area of canvas, so small that I want to cancel out any attention on it. Dark backgrounds focus singular attention on subjects. I often start relating my colors to a dark background and after I have developed the subject's colors, I introduce a somewhat lighter tone to it, especially in the area around the subject.

The best way to paint richly colored dark backgrounds is to do them in two coats of paint. The first coat should be a light-toned version of the color you want the background to be. If you want a dark orange background, for example, paint the background area with a tone of Burnt Umber, Grumbacher Red, a little white and Sap Green. After it has dried, and the painting has been developed, glaze over it with Burnt Umber and a touch of Alizarin Crimson. (For more information, see Chapter 17, *Coloring by Glazing.*) The lighter dark tone under the even darker glaze will inject luminosity into a dark background color.

I particularly like using Indian Red and black as a dark, warm-colored background in a painting. Indian Red is strong and rather opaque, so this mixture's covering power is strong and the red is not killed as it is darkened by the admixture of black.

For seemingly blackish backgrounds, I mix a color and its complement instead of using black itself.

a subject's dramatic advantage...

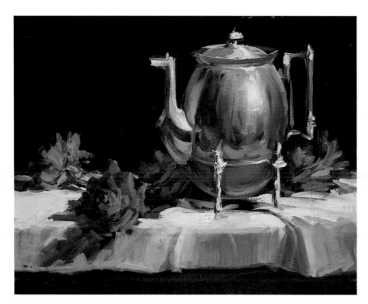

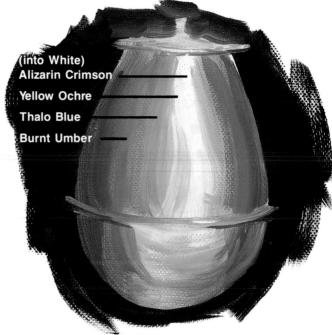

(into White)
Alizarin Crimson
Yellow Ochre
Thalo Blue
Burnt Umber

A silver object is so shiny that its surroundings reflect onto it dramatically. These alluring reflections are usually seen in the object's shadows, but don't let them lure you into making them as light as the object's highlights. The swatch shows the important highlight that describes the pot's roundness, a factor that's just as important as the object's shine.

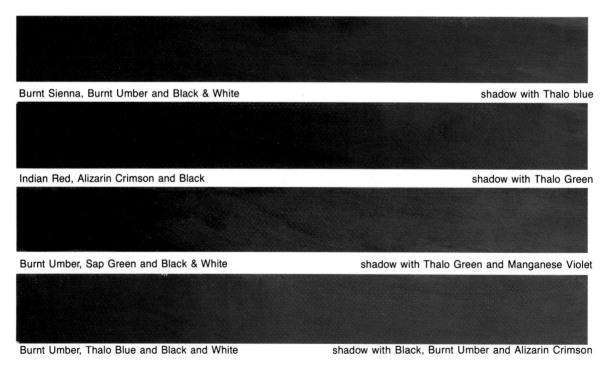

Burnt Sienna, Burnt Umber and Black & White shadow with Thalo blue

Indian Red, Alizarin Crimson and Black shadow with Thalo Green

Burnt Umber, Sap Green and Black & White shadow with Thalo Green and Manganese Violet

Burnt Umber, Thalo Blue and Black and White shadow with Black, Burnt Umber and Alizarin Crimson

Since subjects so often cast shadows on backgrounds, dark background mixtures have to be light enough in tone to be able to shadow them with their colors' complements. Dark backgrounds look more luminous if they are done with two thin coats of paint than with one thick coat.

...the painter's advantage as well

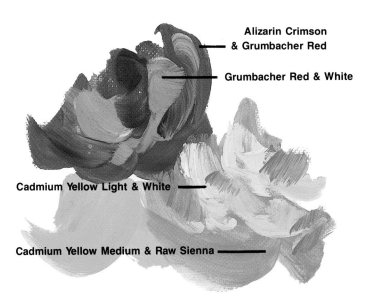

Alizarin Crimson & Grumbacher Red

Grumbacher Red & White

Cadmium Yellow Light & White

Cadmium Yellow Medium & Raw Sienna

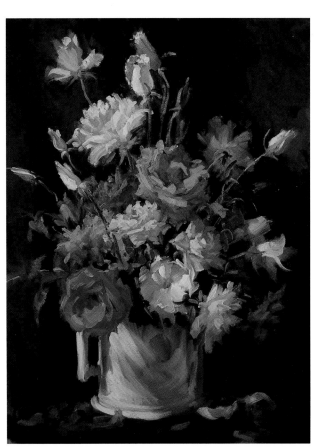

Amounts of white thicken a color mixture and make it one that is easy to apply on top of colors that were more thinly applied. A dark background enables you to lay in a subject's color in a tone not as light as its body tone but not as dark as its shadows. Additions of lighter and lighter color mixtures define the subject as well as making it stand out from the dark background.

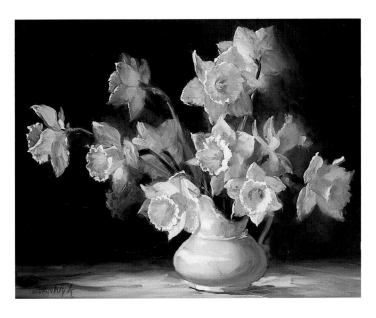

Cadmium Yellow Light

Cadmium Yellow Light and White

Manganese Violet

The delicacy of the daffodil was easier to record against a dark background because its dark tone could be seen through the flower's thin petals, making their mass tone color quite grayed. Shapes of thick, lighter, brighter yellow mixtures were added to the basic grayed mass tone to record the light on the flower and also the light that passed through its semi-opaque texture.

lesson #7

Project: Using the technique of glazing to paint flowers on dark backgrounds
Medium: Three parts linseed oil to one part turpentine
Painting time: Four hours for each painting

Among commercial house painters, there is no question about how many coats of paint are needed to adequately cover a surface, be it dark paint on a light surface or light paint on a dark one; one coat isn't enough to do a good job. In fact, I'm sure when many of **you** have had to paint a room, you've done so with two coats of paint. Two coats look better than one, they are easier to apply and they are not as apt to peel or crack. How come, then, this technique, which is so readily accepted for walls and woodwork, is distressingly ignored when it comes to painting pictures? Can it be that artists are so excited and anxious to see how their impressions are going to look on canvas that they become too impatient to use two coats of paint?

I do most of my paintings in two coats; the first one is called an underpainting. I especially do an underpainting for paintings with dark backgrounds.

This lesson will teach you that paintings done with two layers of paint are easier to do because they simplify the process. They look better because glazes of color can be used in the process and then will be less likely to crack since thick paint doesn't have to be used to cover the canvas.

The monochromatic (black and white) tonal renditions of the basic elements of my subjects were done with acrylic paints thinned with water. Underpaintings done with acrylic paint dry in about thirty minutes, at which time I can paint over them with my oil paints, starting with colored glazes and finishing with thicker opaque colored mixtures. (Before doing this project, I suggest you read Chapter 17.)

Helpful hints: Glazes are thin but not runny. Wet a brush with your medium mixture. The dampness is enough to spread color out as a glaze.

On an underpainting of daffodils.

1. Glaze the daffodils with Cadmium Yellow Light and Yellow Ochre.

2. Glaze color on the vase and table.

3. Glaze color on background (Burnt Umber).

4. With lighter yellow colors add lights to perfect the flower shapes. Add a different light yellow color for the reflections. The glazes over the gray underpainting become the shadowed color of the daffodils.

On an underpainting of roses.

1. Glaze colors on the flowers, extending it beyond and out into the background to assure good coverage.

2. Glaze Sap Green for the greenery.

3. Glaze Burnt Umber and Alizarin Crimson over the dark underpainting of the background.

4. Finish the flowers by adding light, bright colors, leaving the darker glazed areas to act as shadows.

12

SUBJECTS AND THEIR BACKGROUNDS

In my chapters on light and dark backgrounds (Chapter 10 and Chapter 11) I told you about how the *tone* of a color influences the subject. The focus of this chapter is on how to choose *colors* for backgrounds. At the same time, I will teach you how to make a gradation of colored background from light to dark, a type of background that I particularly like to use.

I decide background colors by a process of elimination. I begin to examine the possibilities. My first limitation is the color's tone: I can't easily use a light background for a lightly colored subject or, it follows, a dark one for a dark colored subject. And medium-toned colors, such as reds and violets, can't withstand medium-type backgrounds. I also consider the subject's intensity of color, ruling out bright backgrounds for bright colors, and dull ones for drab subjects. I don't rule out completely the same color as the subject. In fact, it is a safe choice. Of course, it must be a contrasting tone to the tone of the subject, and the intensity of the color should be greatly changed.

My choice narrows down to a color that is relatively complementary to the overall coloration of my composition or an element in the composition.

A successful-looking background depends more on how it is executed than on its color. I spend hours on my backgrounds, especially the ones that are a tonal gradation from light to dark.

There are three major areas of backgrounds that warrant your attention:

1. *Where it meets the subject.* Overlap the paint into the subject's edges instead of to its outline. This area of a background has to look as though it continues around and in back of the subject. The subject's shape can be repaired later.

2. *Where it meets the canvas edges,* calm down any activity of tone, color and brushwork.

3. *The space between the subject and the edges of the canvas.* This area should join interestingly. The best way to deal with it is not to have much of it. If your subject is so small that there is a lot of background, the best cure is to cut the canvas down in size.

Types of backgrounds are largely a matter of personal taste.

☐ I feel that a background should continue the spirit of the subject: dramatic people, dramatic backgrounds; earthy subjects, earthy backgrounds; elegant subjects, elegant backgrounds.

☐ Roughly painted subjects should have roughly painted backgrounds. Conversely, smooth backgrounds for smoothly rendered subject matter.

☐ I always prefer warm backgrounds, either actual warm colors or warm versions of cool colors. I do so because I feel that the warmth of the light shining on my subject must also influence the color of my backgrounds.

☐ Colorful subjects look well against a colorless background; less colorful subjects might need a colorful background.

☐ Background colors should not jump out and fight the subject for attention. That's why the more muted versions of colors are best. Don't ever be afraid of mixing color into puddles of black and white for a background. It imparts that toned-down quality that a color needs to be a background color, your mixture will have good covering power and it will withstand additions of color and tonal adjustments.

backgrounds and their brushwork

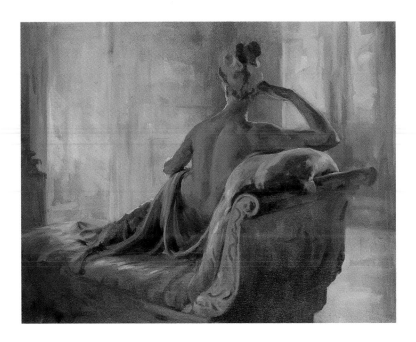

In the Borghese Gallery in Rome, there is a magnificent—and courageous—work of art, a marble statue by Antonio Canova (1757-1822) that he called **Conquering Venus.** The sculpture is a life-sized likeness of a nude Pauline Bonapart Borghese, the sister of the French dictator, and is a superb example of the **neo-classic** style of art. It is lovely from every view, an example of Canova's artistic taste and expertise as a sculptor. As painters, you have to marvel at sculptors composing in the round, since many of you have enough of an artistic struggle with but one view of the subject. I've seen this Canova masterwork many times, each time more impressed by the tender interpretation of her cool, aloof beauty. Using photographs of the statue, taken on our most recent visit to Rome, I painted this view.

In this book on color mixing, I've tried to concentrate my teaching on practical, useable information, hoping that it will help you paint better and find more satisfaction in your efforts. Since I don't know what subjects you are interested in painting, I hardly can give lessons on how to paint, let's say, a moose, or a lit candle, or the sun coming up over ocean waves, to cite but a few of the many kinds of paintings that I've seen others paint. It is up to you to apply your understanding of the basic painting principles and techniques to your choice of subjects. With this in mind, may I suggest that you make your artistic career more a pursuit of **how** you paint rather than **what** you paint. We admire the masterpieces done by the great painters of the past because of their wonderful interpretations and pictorial presentations, sometimes even finding their subject matter not that appealing.

It's hard enough to paint the ordinary and common let alone trying to paint the exotic and unfamiliar. I hope this directs you to be inspired to paint things that you know, see and experience. If you have to reach into your imagination instead of your educated memory, your subjects will look like imaginary people, places and things instead of artistic interpretations of them.

backgrounds from light to dark

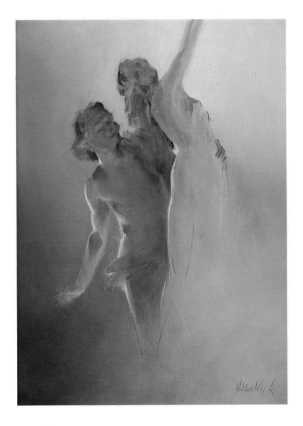

A realistic-looking gradation of a color from light to dark is not done by just lightening one color. That type of gradation will look flat and raw. In nature all colors are influenced by the three colors in light. So it's logical that three colors have to be used on canvas, too. See how the yellow and violet colors in ''A'' alternate as the tone darkens; it's the color-and-complement theory again in practice. These bands of color were then blended together, as seen in ''B.'' When grading a background from light to dark, always start with a light tone of the actual color, then add its complement into that puddle, then into **that** puddle, add a darker actual color, then darker complement color, and so on and so on until you reach the edges of the canvas. **Great fun!**

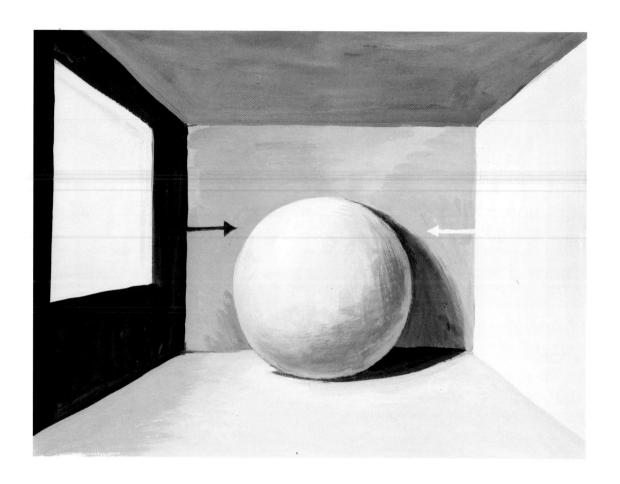

why the background is dark
where the light comes from

Back to the ball for another lesson on basics, this time to help you understand why backgrounds are dark on the side of the canvas where the light comes from. The color and tone of the background that you see immediately adjacent to your subject does not have to be the color you use for your painting's background. Your background area can be more inspired than that; inspired by the fact that you want your background's colors and tones to suggest space. You can accomplish this by incorporating the tones of the entire room into your backgrounds. Do so by using the dark tone of the room against the light tone of the subject, and the light tone of the room against the dark of the subject. Arranging tones this way in the background area makes it essential to know how to grade a color from light to dark.

13

THE INS AND OUTS OF FOLDS

Beautiful renderings of folds of draped cloth can be seen in every art museum. Visitors to the galleries where the formal portraits of the English gentry hang, marvel at the texture and folds of elegant satin and brocade.

The drapery on the figures in the myriad religious paintings of the Italian Renaissance is painted with lovely colors, not to mention how accurately the folds conform to their bodies' movements and anatomy. Renderings of cloth in many different compositions seem to have been done with ease by even the lesser painters of the period.

Today, the need to paint drapery well remains. One, obviously, is in portrait painting, where you are always faced with doing clothing and perhaps, at times, when you might like to use drapery to excite or soften a background. In still life painting, drapery is often used as backgrounds or as essential parts of a composition in the form of embroidered or lace table cloths or just plain kitchen towels.

I feel that a chapter devoted to painting drapery can serve two purposes: it will prove that the basic principles of color and tone can be used to render any subject, even the ins and outs of the folds; it will also give me a chance to stress the necessity of using an efficient procedure of color application when faced with a complex, confusing subject matter. All the tones of light and dark that you see on all the folds as they hang next to each other are confusing and if you try to paint all of them in one application, your rendition might well record your confusion. To paint complex subject matter, you must resort to doing it in simple stages of development. I find that I use two distinct applications of paint to record drapery:

1. This first stage records the shape of the shadow areas as one tone. This shadow area is made up of the body shadows and the darker cast shadows, but during this first stage, I paint them both only in one tone of shadow color. You have already learned that a shadow color is relatively complementary to the color it is on. To review: In the case of a red drape, the shadow color would be red, darkened and reduced in intensity by green. I substantially paint in the light areas with the actual color of the drapery (red plus some white). This first stage of painting drapery should not be thought of as a merely preliminary indication to be repainted. The canvas should be completely covered with the tone of the dark pattern and the tone of the light pattern because the additions of paint of the next stage of development never completely covers the first coverage.

2. Now I paint in the lighter tones I see within the light areas with a new mixture, not just adding white to the original light tone mixture. In many cases, it's a highlight-type color. In the case of the red drape I'm using as an example, the mixture could be red, orange and white. I add more red coloration on to the shadowed areas and paint even darker shadow color to record the cast shadows.

To sum up this two-part procedure, paint the light and darker areas. Then add lighter light tones to the light area and darker darks to the dark areas. I introduced you to this basic procedure in Chapter 4.

arranging drapery

"Kisses" on canvas result where two shapes just touch. These kisses are detrimental to composition, dimension and the sensibility of the shapes involved. Compare the kissing drapes in "B" to the painting to see why **you can't kiss on canvas.**

If you arrange drapes to hang in sausage-like folds, it stands to reason that you'll paint them to look like sausages. If you arrange folds in a confusing array of meaningless shapes, your painting of them will be more of a distraction than an asset to the composition.

helpful hints on arranging drapery

1. Try to have an uneven number of folds.

2. Make the folds near the subject the important ones.

3. Don't make all the folds the same width.

4. Don't let folds go off the edges of the canvas.

painting drapery

When I entertain during the spring months, I use this tablecloth with my green dinner china along with a centerpiece of yellow and white daisies. Notice how the folds vary in shape and size and how the shadows contrast the bowl advantageously. It takes me quite a bit of time to arrange a drape, making sure that there are no "kisses," repetitions or confusion. I try to arrange the folds in a way that I can see the five tone values per fold: 1) **body tone;** 2) **body shadow;** 3) **cast shadow;** 4) **highlight;** 5) **reflection.** A general technique for painting a fold is to apply the paint across its shape rather than up and down in the direction that the material falls. Its up-and-down effect is obvious. The less obvious but "oh-so-important" factor of a fold is its in-and-out dimension. Painting the tones of the fold in across strokes permits you to blend them all in with up-and-down strokes. Save the obvious for last. **The first things you see should be the last things you paint.** In this particular drape, the applique and embroidery were added after the folds had dried.

The beginning stage of any painting should record your singular concentration on the placement of your subject. It, and its immediate surroundings, becomes the all-important focal area. Many hours of painting with beautiful color will never correct nor compensate for a bad composition.

A practical way to simplify all the tones of drapery: By mixing up two puddles of paint on your palette—one for the light tones and one for the dark ones—you'll be forced to see and paint only the two basic shapes, that of light and shade.

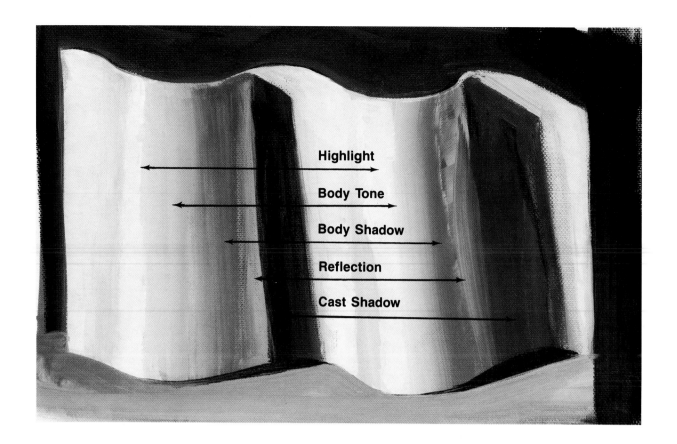

Highlight

Body Tone

Body Shadow

Reflection

Cast Shadow

the anatomy of folds
and reflections

Because reflections contribute so much dimension to folds, this is a good time to explain their characteristics.

A reflection is that intriguing, lighter tone seen on the shadowed edge of an object. It is one of the five tone values caused by light. In Chapter 4, I called reflections the "shadow spoiler." I did so because if it is incorrectly painted, the dimensional effect that shadows impart is really ruined. My main instruction about reflections is **caution.** Don't make them as light as you think they are! They may look light to you because they are surrounded by the dark tone of the shadow. You must compare their light value to the light value of the directly lighted area. You will then see them in their "true light," not really as light as you think.

These are the do's and don'ts to help you paint reflections correctly:

1. Save them for the very last application, embedding them into an already painted-in shadow.
2. Never make them of a mixture of a color and white. That mixture will always be a "shadow spoiler."
3. Always make reflections by adding their color into a slightly lightened mixture of the shadows they are in.
4. Reflections are caused by the color and tonal conditions of the surroundings and the closer the conditions are the more effect they will have on reflections. The nearness of one fold to another makes reflections in the shadows of drapery so obvious.
5. Colorful surroundings cause colorful reflections; light surroundings cause light reflections.
6. Strong lighting on light surroundings intensifies the appearance of reflections.

In conclusion, reflections add beauty and dimension to shadows and are hard to resist. You can't ignore them since the dimensional quality of your pictures needs reflections. But, please, **handle with care!**

14

SEEING SHAPES
OF COLOR

The phrase, "I can't draw a straight line," is the one most often used by people trying to explain why they can't paint and won't try. However, once a person *tries* painting, and manages to do it rather well, the catchphrase is *still* used, this time in reply to compliments. The artist *now* is heard to say: "...*and* I can't even draw a straight line."

To equate drawing with painting in any case is wrong to do. You will have more success with the painting process once you reach the conclusion that drawing and painting are not at all alike. While it's true that both actions result in images on a surface, the process for and the appearance of a drawing and a painting are completely different. The only similarity that both painters and "drawers" share is how *proportion, perspective* and *anatomy* influence the rendering of shapes on a flat surface, be it canvas or paper. There the parallel ends.

A pencil is used to make a drawing by outlining shapes. A brush, on the other hand, is used to make a painting by filling in shapes. Be a painter, not a "drawer" and don't use a brush as you would a pencil. Forget that you ever held a pencil in your hand. This will lead you to an entirely new thinking process, one that will enable you to manipulate a brush in a way to fulfill the three basic functions of the instrument:

1. To fill in an area. As little as a dab or as large as a background.

2. To make contrasting tones meet, thus creating a "line."

3. To blend the contrasting tones together.

Painting is as simple as that. The difficulty of painting is trying to make these simple actions recreate your impressions of this wonderful world.

For the meanwhile, the purpose of this chapter is a practical one. It will alert you to being a painter instead of a "drawer" by making shapes of color with brushes full of colorful paint.

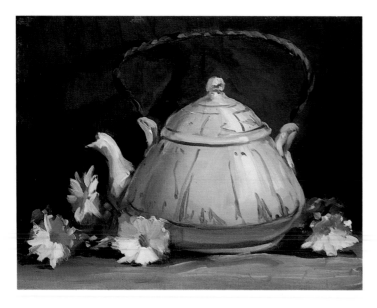

lesson #8

Project: A simple still life arrangement
Canvas: 12 x 16
Painting time: 2 hours

Do a simple still life arrangement such as this one, using this basic painting technique. Many people think that the basics are only used by beginners. Not so. This procedure is so reliable that all your other painting experiences will be your clever interpretations of it.

1. Sketch in the placement and shape of the subject.
2. Paint the background with black, white, Burnt Umber and Burnt Sienna. Add the shadow on the background by adding Alizarin Crimson and Thalo Blue to the basic background mixture.
3. Paint the pot with white, Burnt Umber and Yellow Ochre. Add the shadows using Thalo Blue and Alizarin Crimson.
4. Mass in the flowers with black, white and Yellow Ochre.
5. Mass in the table with a little black, white and Burnt Sienna.
6. Add the spout and handles with pot color.
7. Add the handle with white and Burnt Sienna.
8. Add light tones to the pot with white and Yellow Ochre and then even lighter tones with white and Alizarin Crimson.
9. Add lighter tones with white and Yellow Ochre in petal-like strokes to the flower mass and to the centers with Raw Sienna.
10. Add light to the table with white and Burnt Sienna.
11. Add the blue pattern to the pot with Thalo Blue that's been greatly thinned with turpentine.

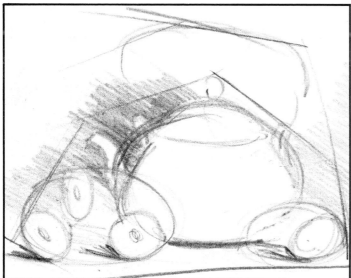

the 3 paint applications

seeing
color on color

The weeds were painted by adding their tones onto the canvas with the tip of the brush loaded with color. The tones of the pattern on the vase were put on by pushing paint onto the vase's basic color.

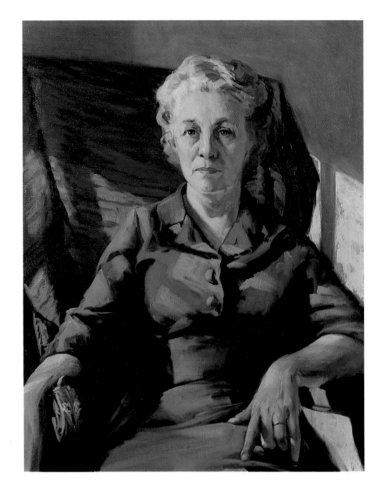

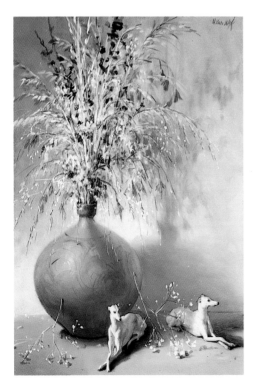

The phrases, ''wet-into-wet'' and ''painting into paint,'' describe the second stage of an oil painting's development. It is the ''fun'' stage only when it's done to a well-planned basic stage. See how the sunlight was added by skimming lighter, brighter mixtures over Mother's dress and the drape on the chair. This was done after the areas were somewhat dry.

shaping with paint

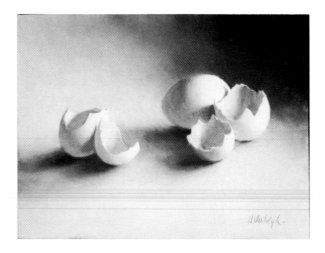

An analysis of my oil painting technique is simply that of overlapping. I'm constantly overlapping or cutting into an already painted area with a contrasting tone to make a shape. I rely on this technique all the time, particularly in "close quarters." The following steps show how I used my overlapping technique to paint an eggshell (an example of close quarters):

1. The tone of the background was overlapped into the back of the egg.

2. The light tone of the eggshell was painted up against the background, extending it down far enough to overlap it with the next step.

3. I moved the shadow on the egg against the light tone forming the thin thickness of the shell. I painted this shadow tone beyond the front shape of the shell and blended it into the light tone of the shell on the left.

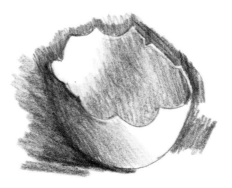

4 & 5. I overlapped the light tone of the front shape of the shell up and over the shadowed inner part of the shell only on the right, using a dark tone on the left. The bottom of the shell was shaped with the dark cast shadow tone.

15

SEEING
THE RIGHT SHAPES
OF COLOR

Learning how to judge *proportion*, understanding *perspective's* effect on shapes, and being aware of the *anatomy* of forms will help you to be a better painter because you will be able to see and set down subjects correctly.

Let's start understanding proportion by describing the characteristics of a square shape: Its height and width are the same size. Its proportion, then, is even or the same. A rectangular shape has one side larger than the other, so its proportion is uneven, and it is up to you to see how different these two dimensions are.

All your subjects are going to be rendered on a flat surface and will have a height and width dimension. Judging these in relation to one another will enable you to arrive at the correct proportion of your subject's shape.

When two squares of the same size are seen next to one another, they are obviously the same size. As soon as one is moved farther back from the other, its size will be, from your point of view, smaller.

Comparing the proportion of one size to another, as you see it either close to you or far away, will help you to place things in proper perspective to each other. The major factor that perspective plays on shapes is alteration of their sizes.

I know that this is a simplified analysis of a factor of painting that is highly important. It is a reliable, practical one, though. By judging a subject's height dimension in relation to its width, and the size relationships of one subject to another, I can indicate correctly sized masses in perspective on my canvas. My understanding of my subject's structure then helps me turn these masses into recognizable shapes.

As much as I advocate the shape-making process by teaching you to mass in forms instead of drawing in the forms, I hope I haven't mislead you to think that drawing isn't important to painting. You must train yourself to *see* proportions, you must *see* the effect perspective has on things, and you must *see* the structure of your subject matter. Drawing better is seeing better.

seeing in proportion and perspective

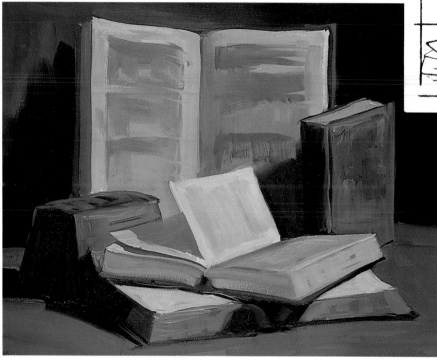

The most difficult predicament you have to overcome when faced with a subject is that its magnitude of shape, tone and color is constantly in front of you, just waiting for you to find a simple beginning. The shape, of course, is the primary consideration and even **that** is complex and needs simplifying. Always start with a shape's proportion in relation to the canvas and then to its own proportion. A little bit of mathematics is necessary to help you with proportioning.

In the diagram of the books, you find that the height of the book's shape is only one-third of its length.

The diagram of the shoes shows you that in this view the sneakers are no longer the same size. These proportions put the subjects in proper perspective. I'm sure you'll be able to paint things in better perspective if you search out the proportion of your subjects.

a way to get the right shapes

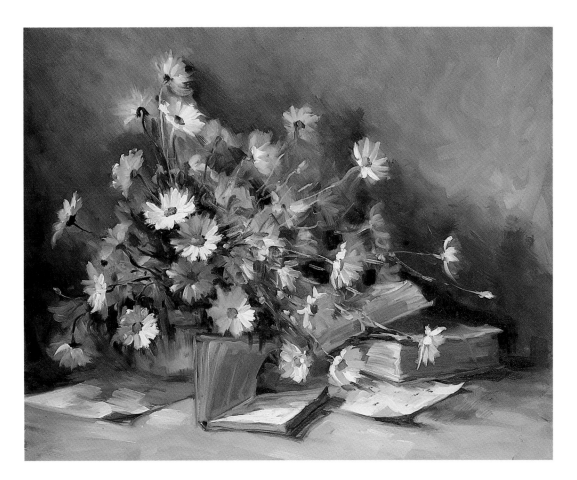

The three thicknesses of line show the three simple steps you can use to arrive at correct shapes: 1) proportion of the composition in relation to the size of the canvas; 2) the proportion of the elements of the composition; 3) the actual shape or structures of the subjects.

the ellipse — a circle in perspective

Perspective's effect on a circle is an excellent way to show you that perspective doesn't change a shape; it only makes a shape appear to be a different shape. A circle fits into a square or box and its arcs touch the middle of each side of the square. They also intersect the square's diagonals two-thirds out from the middle of the square.

Seeing a square in perspective, such as lying flat on a table, makes the front and back sides of the square appear closer together and the back one smaller. The diagonals still go from corner to corner. The middles of the receding sides are closer to the back side. From a direct front view the center of the front and back sides is still in the middle of each.

See how a circle has taken on a new shape but its arcs still touch the sides and diagonals of the square shape drawn in perspective the same way.

16

BUILDING COLOR
WITH BRUSHWORK

Application of color mixtures has a strong bearing on the way color mixtures look. Brushwork can make color mixtures look exciting and vibrant and, unfortunately, sometimes make color look dead. There is a basic, reliable type of brushwork that gives your color mixtures an advantage. It is that of applying colors in opposing stroke directions instead of applying colors in all the same direction of strokes. The opposing strokes of color can be set down next to each other or on top of each other. They can also be used to blend in areas of color. A combination of opposite brushstrokes instills some identity and character into the paint. Painting an area of color with opposing strokes excites the color. Blending color areas by using opposing strokes fuses the color, leaving slight variations of the color's intensity which seems to impart a more vibrant color presentation than an area that has been completely blended in.

You have learned that balance is as important in painting as it is in nature and how opposites can strike that balance, as in:

□ Colors and their complements are opposites
□ Warm and cool colors are opposites
□ Light and dark are opposites
□ Bright and dull are opposites

Now, I've introduced another balance, that of brushwork. Opposing strokes respect the dictates of nature's balance. Doing so serves a more practical, less erudite, purpose. It helps to fashion dimension: One direction of application — one dimension; two directions of application — two dimensions. Use contrasting tone and the feeling of the third dimensional effect is yours.

strokes of color next to each other

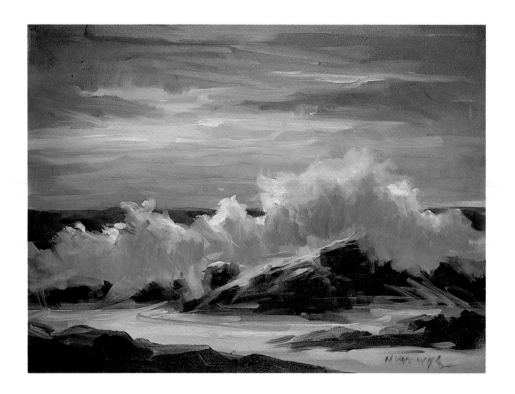

Try to think of your canvas as a surface that is going to support the paint you will use to record your subjects rather than a surface to be covered with your paint. Doing so will make your brushwork begin to excite your paint with dimension. Here, in a diagram of the brushwork I used to paint an ocean wave, you can see a suggestion of dimension.

strokes of color on top of each other

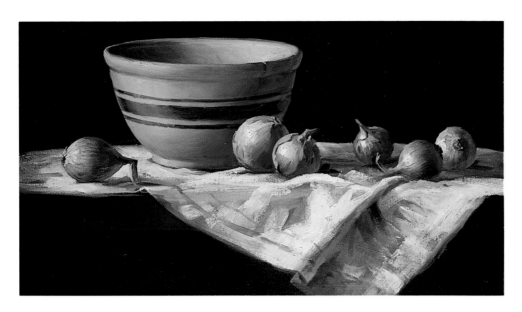

The textures of many subjects are quite complex. An obvious example is the layers of translucent skin of an onion. Painting its texture and its round shape well can be done with layers of opposing brushstrokes. Try to translate the elements of a subject's complexity in terms of brushwork and layers of paint. The sum total will record a subject's appearance.

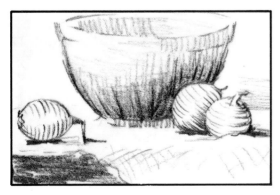

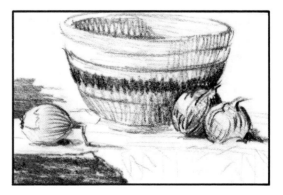

lesson #9

Project: Exciting brushwork. Copy the ocean wave painting on page 74
Canvas size: 18 x 24
Painting time: 2 hours

Make this lesson concentrate on improving brushwork. Use a #8 filbert brush for the entire lesson and load it with lots of paint per brushstroke. Squeeze out a lot of white on your palette (a heaping tablespoon). You will also need a little Cadmium Orange, a lot of Yellow Ochre, Raw Sienna, Burnt Sienna, Burnt Umber, some Thalo Blue, Alizarin Crimson and Ivory Black. Clean your brush between mixtures by vigorously sloshing it into a half-filled coffee can filled with turpentine.

1. Sketch the composition.

2. Using the diagram as a guide, stroke in brushfuls of white and Yellow Ochre with a touch of Thalo Blue in the light sky area. Vary the mixture per brushful.

3. Cut down the light area with the cloud mixture of black, white, Thalo Blue and Burnt Umber, and color in the rest of the sky area with short up-and-down strokes.

4. With horizontal strokes paint in to the clouded area, especially toward the water with gray made of white and Burnt Sienna. Try to do your brush stroking with a fluid motion by holding it loosely near its end.

5. Paint the distant water (black, white, Thalo Blue and Burnt Umber) not too thickly.

6. With brushfuls of a thick amount of white and a touch of Yellow Ochre, paint the shape of the light on the wave. Pull this paint up over the sky and paint it down into the shadow area of the wave.

7. Cut the light of the wave down with black, white, Burnt Umber and Thalo Blue shadow color.

8. Cut the shadow of the wave down with some light water and light rock color made of Burnt Sienna, Cadmium Orange and white.

9. With Burnt Umber, Alizarin Crimson and Thalo Blue, cut the light top plane of the rocks down with the shadowed side plane of the rocks.

10. Now cut the bottom of the rocks off with black, white and Thalo Blue.

11. Add light tones of water with white and Yellow Ochre.

12. Chop in the rock on the left with light and dark rock colors and do the same with the foreground rocks on the left.

To sum up: This brushstroking of color will look better if you incorporate the overlapping you learned on page 64.

17

COLORING
BY GLAZING

Here is a way to understand glazing with color (or applying a glaze): Visualize a black-and-white photograph covered with a piece of red cellophane (or a red acetate sheet). All of the tones of the photograph would be in tones of red instead of in black and white. There, in a nutshell, is the process of glazing: the photograph represents a monochromatic underpainting; the transparent red cellophane acts as a glaze does.

Let's apply this illustration to glazing with paint. When most oil colors are thinned with any type of medium, be it linseed oil, a prepared medium, varnish or even turpentine, and applied over a pre-painted (and thoroughly dried) area, they form a coating much like the red cellophane did over the photograph.

Transparency is a characteristic of oil paint that few people know about, since the first and foremost image of oil paint is one of thickness and opacity. While there are certain oil colors that are classified as opaque or semi-opaque, the addition of a *medium* will transparentize them enough to be applied as a glaze. The addition of *white paint* makes all oil paints opaque, even the very transparent ones like the Thalos and Alizarin Crimson. Colors mixed with white cannot be applied as a glaze.

Paint's transparency is useful as well as beautiful. Color glazed over a monochrome or other color is clear and luminous looking. A transparent glaze can add more color, or color correct an area. It can darken an area, even tone down a color as well as enrich a colored area.

To understand the valuable contribution that glazing can present, you must accept one essential factor about color and color mixing: the *correct tone of a color* determines two-thirds of its being a successful mixture. The tone of a color (how light or dark it is) establishes a color's brightness or dullness as well.

The other third of color mixing success is relatively easy, that of adding to the tone and intensity the peculiarity of the color's hue.

This chapter on glazing will help you understand color and color's tone, and will surely add to your color mixing skill.

glazing's not a mystery

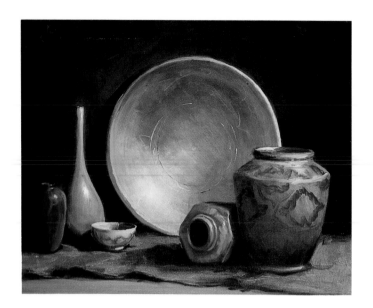

Before glazing this picture on my television show, I had prepared, off camera, its underpainting in tones of gray: black and white acrylic paint thinned with water. The technique of glazing color onto an underpainting was more widely used four or five hundred years ago when tubes of color were not as easy to come by as they certainly are today. Underpaintings in those days were prepared with egg tempera, a water-based, fast-drying medium. Acrylics are water-based and fast-drying, but there seems to be some question among certain people about the wisdom of painting oil over acrylics. I can only reply by wondering about the painters of the past. Did they worry whether their glazes of oil over tempera would ever survive future generations? As far as I'm concerned, that's the only mystery about glazing.

it's simply using transparent color

In this chart, I painted little squares of color, thick enough to cover the canvas. I then painted a thinned-down version of the color—a glaze—over a gray ranging from light to dark. This diagram clearly shows how a glaze of color is lightened by the light tone and darkened and dulled by the dark gray tone.

Thalo Blue

Thalo Green

Raw Sienna and Cadmium Yellow Medium

Grumbacher Red

glazing in action

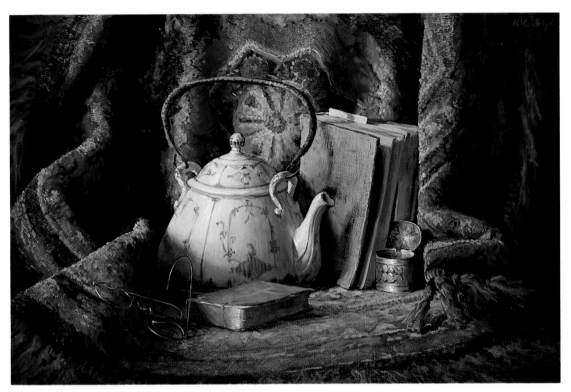

I am sure that you recognize my old Holland cocoa pot as the same one I used in **Lesson #8,** but you can also see how different it looks in this painting. The reason—it was started with an underpainting, as was the entire picture. The extremely complex texture of the old Dutch tablecloth dictated a necessity to use an underpainting-glazing treatment. I had to paint folds, I had to paint a thick, nubby texture, and I had to add a pattern of different colors as well. I did the tones of the folds with the underpainting. I added the colors of the rug with glazes, and finally added little dots of lights and darks with opaque paint for its nubby texture.

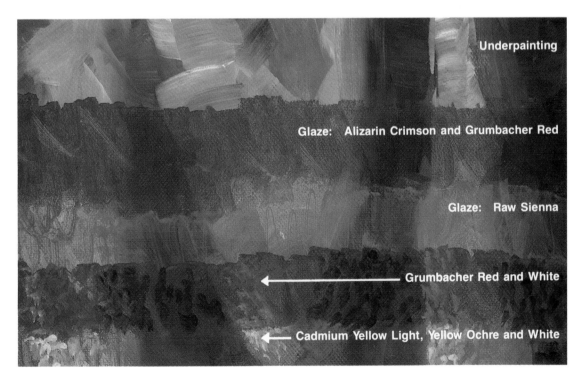

Underpainting

Glaze: Alizarin Crimson and Grumbacher Red

Glaze: Raw Sienna

← Grumbacher Red and White

← Cadmium Yellow Light, Yellow Ochre and White

what underpaintings look like

An underpainting is a foundation coat of paint that adjusts the painting surface to make the actual painting process easier to do. An underpainting can be used as a preliminary step for landscape, still life, portrait, in fact, any type of picture. Sometimes it can be the vaguest suggestion of a composition; other times, a more elaborate rendering. An underpainting has to be thinly applied, with the texture of the canvas clearly in evidence. Oil paint is not an adhesive; it only adheres to the rough tooth of the canvas. Consequently, don't paint underpaintings smooth and thick.

The three underpaintings, shown here, epitomize the various extents of the tonal rendering I do to prepare for the glazing technique.

Self portrait on page 38

▲

I use an underpainting in my portraits to establish the size and placement of the head, a simplified rendition of the lights and darks on the face, the tone of the background, and the clothing.

▶

My still life underpaintings are more defined but not detailed.

Still life on page 30

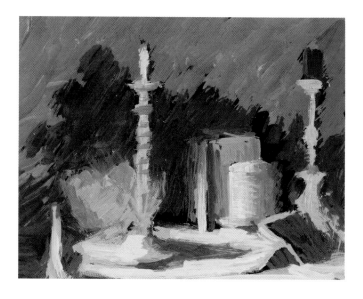

◀

When painting outdoors, I simply wash in the basic tones, usually sky, middle distance, foreground and focal point.

Landscape on page 82

I call my underpaintings my pictures' security blankets.

18

HELPFUL THOUGHT MIXTURES

Many people try their hand at painting only to quit because they find it too frustrating. Surprisingly, lack of talent isn't what drives them from the easel; their frustration seems to stem from their inability to accept the difference between reality and paint. Students of painting suffer from this problem, too, when they believe they have to make a tree out of leaves instead of paint, and think a brush can actually bring the sky down onto a canvas. Once they realize that the *look of the paint* is the only way to recreate the subject, they will have conquered the major frustrating part of painting.

From the look of my paintings, people have conjectured that I paint well because I am a perfectionist. Absolutely not! Perfectionism in painting is too frustrating. I only try to make the "best of it." The best of what paint can be and what paint can do. Paint can't be the tree or the sky; I translate them with brushstrokes of paint, mostly in a layer that more than adequately covers the canvas. I make mixtures of bright or dull colors that are either light or dark and, by a well-thought-out procedure, I make the contrasting tones fit together to record the shapes of a composition.

I'm frustrated, all right, but my frustration is not about painting; it's the pressure of not having enough time to paint. I overcome this by being well organized with my time, practical with my procedures and efficient with my materials.

For those few times that I get out of my studio to paint landscapes, I have some medium-toned gray canvases on hand in sizes from 9 x 12 to 18 x 22.

The changing light outdoors adds to my pressure of time; I can only work for about two hours, making a canvas larger than 18 x 22 more ambitious than practical. A toned canvas (prepared with acrylic gesso toned with black or violet) is easier to paint on than a white one. I can lay in light patterns of color and immediately see their shape and effect as they contrast the gray tone of the canvas.

I liken painting outdoors to a mini vacation from my studio—two hours of enjoying the air and excitement of the location. Practical attire starts with a hat (a bill on it to shade my eyes), clothing that will not reflect color onto my canvas, and ends with thick-soled shoes (even dry grass will get damp from standing on it in one spot). Finally, I always have insect repellent since oil paints seem to attract bees.

I don't load down my French sketch box easel with a lot of stuff I don't need. I make sure I have a lot of white paint, and scale down my palette to the colors that I use outdoors: Cadmium Yellow Light, Thalo Yellow Green, Cadmium Red Light, Grumbacher Red, Yellow Ochre, Raw Sienna, Light Red, Burnt Umber, Burnt Sienna, Sap Green, Thalo Blue, Alizarin Crimson, Thalo Green and Ivory Black. Five brushes, rags and a large container of medium (made of five parts turpentine, one part linseed oil) round out my equipment. I use this medium for cleaning my brushes between mixtures and wetting my brush to help spread the paint.

I always set my easel up to hold my canvas in shade. The tones of color mixtures set down on a sunlit canvas are hard to judge and are hard on my eyes.

Our visits to Italy are never long enough for me to paint on location. I have to resort to working from my photographic references back in my studio in Rockport. I refer to them to recall my actual visual inspirations, which leads me to clarify a point that's raised in many letters that I receive. In the question of originality, your own photographs are as legitimate as your actual subject matter. When working from photographs or pictures other than your own you should consider them as copies and qualify them as such, with the appropriate credit to either the artist or the photographer.

cape ann themes

Lanesville is a little town on Cape Ann. Views of its harbor have provided artists, from well-known professionals to aspiring students, with refreshing ideas for paintings. Early morning, late afternoon light offer wonderful contrasts to seemingly uninteresting vistas. This little old shack is used for fishing gear; it is outfitted with a stove and an easy chair for the fishermen to wait for the tide, I would guess. After I placed the composition (off center, of course), I proportioned all its surroundings to it. My main area of concern: the tone of the distant trees in relation to the light on the sand of the middle distance, the top plane of the stone pier and its shadow.

I did **Boats** on one of my television shows to teach how to paint reflections in still water. This is another example of a complex texture—reflections into the water and the surface of the water. I relied on two directions of paint application: the tones of the reflections in down strokes; then across strokes to suggest the ripples. I worked from a black-and-white photograph as a reference. This subject and foggy days are familiar to anyone who lives on Cape Ann.

From a photo by Bart A Piscitello, Gloucester (Mass.) Daily Times

The Bridge at Good Harbor Beach is the center of interest in this picture, principally the bridge's footing on the left. I began this picture by placing and sketching the bridge just to see how it looked. My drawing of it was almost entirely obliterated by my painting process, especially the colors of the marsh and water behind it. An initial sketch is not a drawing to be filled in with paint. It's a linear indication or, shall I say, a pictorial memo to yourself of things to do with paint.

italian themes

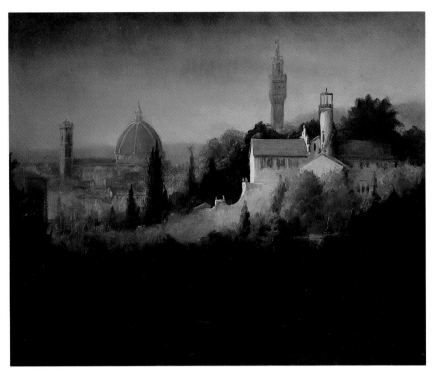

A View of Florence. I was inspired by the early morning misty light on the city in contrast to the light on the small country monastery. I saw this vista on our way to Rome, and even though we were anxious to proceed on our trip, we turned back so I could take some pictures.

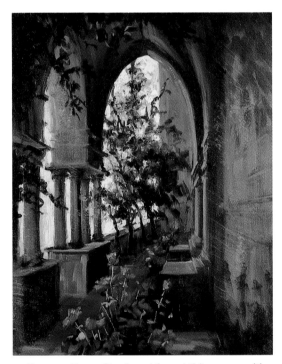

Roman Rose Garden. I found this composition as we walked along the Tiber River. There really was only one rose blooming. I added more to add interest. Besides, one looked too lonely.

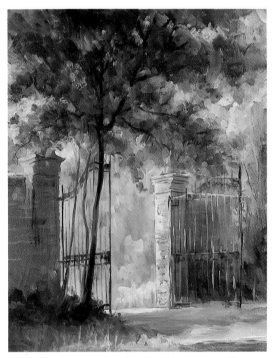

La Principessa is a lovely 18th century villa near Lucca. Now a hotel, its gate in the wall is one of many around the vast, beautiful grounds and gardens. Picasso had his ''blue period''; this painting is one from my ''gate period.''

lesson #10
helpful hints about landscape painting

1. **The Shack in Lanesville.** The red roof surely added the interest that this predominantly green composition needed.

 Distant trees: For various greens, use Thalo Yellow Green and black and white; Sap Green and black and white; Alizarin Crimson, Burnt Umber and Thalo Green and black and white.
 House roof: White, Cadmium Red Light and Yellow Ochre.
 House: Burnt Umber and white; Thalo Blue, white and Burnt Umber for its shadow.
 Sandy road: Yellow Ochre, Burnt Sienna, black and white.
 Top of stone pier: White and Yellow Ochre.
 Side of stone pier: Black, white, Burnt Umber, Burnt Sienna and Raw Sienna.
 Shadow on stone pier: Black, white, Burnt Umber, Alizarin Crimson and Thalo Blue.
 Foreground grass: Thalo Yellow Green, white and Sap Green.

2. **Gloucester Boats.** Bright important colors are assets only to a focal area.

 Sky, water and fog: White, Thalo Blue, Yellow Ochre and Burnt Umber. Paint these mixtures in from the sky to the bottom of the canvas. With a rag, wipe away the paint so you can do the boats.
 Boat cabin: Cadmium Yellow Light, Yellow Ochre and white; shadowed side gray and Raw Sienna.
 Boat hull: Sap Green, black, white and Burnt Umber.
 Red water line: Grumbacher Red and Alizarin Crimson.
 Sailboat cabin: Thalo Blue and white, shadowed with gray.
 Sailboat hull: Light gray and Yellow Ochre.
 Shadow side: Black, white, Thalo Blue and Raw Sienna.
 Reflections in the water: Repeat the boat's color in downward strokes, and then with some across-strokes ripple the water. Add all the rigging last.

3. **The Bridge at Good Harbor Beach.** A simple, good landscape composition is one with a well-defined distance, middle distance and foreground.

 Sky: Cadmium Orange and white; Thalo Blue and white.
 Distant mountains: A gray of black and white, Burnt Umber, Sap Green and Alizarin Crimson.
 Distant field: Thalo Yellow Green and white.
 Marsh sand: Yellow Ochre and white; Raw Sienna and white.
 Water: Thalo Blue, black and white.
 Light tone of water: Thalo Blue, white and Yellow Ochre.
 Bridge: Burnt Umber and Burnt Sienna greatly thinned.
 Bridge footing—light tone: Burnt Sienna and Thalo Blue.

4. **View of Florence.** Don't be enslaved by a photograph by painting its details and its mistakes in composition. When working from a photograph, omit, move, accentuate, diminish! Be a creator not just another copier. I focused attention on the little monastery by contrasting its light tone with dark trees. If I hadn't diminished the tone and details of the dome in the distance, I would have ended up with two focal points.

5. **Roman Rose Garden.** Whenever one of my compositions has a large area of dark tone I do an underpainting. I think transparent color glazed over a dark tone looks more luminous than a thick, dark coat of opaque paint. A medium gray tone for the building was colored with glazes of Raw Sienna and with Burnt Sienna. The darker shadowed areas of the building were added with glazes of Manganese Violet and Burnt Umber.

6. **The Gate at La Principessa.** The three landscape planes in this painting are light distance, dark middle distance (the gate and trees) and medium-toned foreground. Again, red came to the rescue.

 The lights on the red wall: Light Red and white; Yellow Ochre, Cadmium Red Light and white.
 The darks on the wall: Black, white, Light Red, Sap Green, Burnt Umber and Alizarin Crimson.

19

THE WARM COLORS: YELLOW, ORANGE AND RED

The warm colors of the spectrum are yellow, orange and red. Many versions of these colors are seen in nature. How handy it is for us that there are so many tubed versions too! Take yellow, for instance. We have Cadmium Yellow Light, Cadmium Yellow Medium, Yellow Ochre, Raw Umber and even Burnt Umber. I've heard it asked, "Why do we need all these yellows when there is only one yellow in the spectrum?" In nature, there is a myriad of yellows, all from the one that's present in light. For us to paint *all* the yellows we see, we need *more* than one, the ones that give us a chance to mix a full range of tones and intensities of yellow.

Yellow is a primary color, as you well know, which means that it can't be made by using other colors. This is also true of primary red. We are lucky to have a variety of red paints, too. The ones that offer us a chance to paint the beautiful reds we see are: Cadmium Red Light, Grumbacher Red, Light Red (also called English Red Light and not to be confused with Cadmium Red Light) and Alizarin Crimson. You'll notice that I have included Alizarin Crimson here as a red while also listing it with the cool colors as a violet. Alizarin Crimson, you see, is a red when it is *mixed with other reds.* It is a violet when it is *mixed with tones of gray.* Yes, it is a versatile color, one that I find is indispensable.

Orange colors can be made by mixing yellows and reds, but it is handy to have the tubed oranges on your palette: Cadmium Orange, Raw Sienna and Burnt Sienna.

Body tones of yellows, oranges and reds are relatively easy to produce because they already have the warm character of light. Warm light, shining on a warm color, is easy to mix by adding white into any of the warm colors.

A reminder: the cool colors (violet, blue and green) are the warm colors' complements and should be relied upon to shadow the warm colors. Bear in mind that this doesn't mean that you can dip into any violet, blue or green to do so. The type of complement that you have to use is one that will darken the color and reduce its intensity. To illustrate, Alizarin Crimson is a violet but you can't use it to "shadowize" yellow. You have to mix a gray shadow tone (black and white) and add Alizarin Crimson to it.

the comfort of warm colors

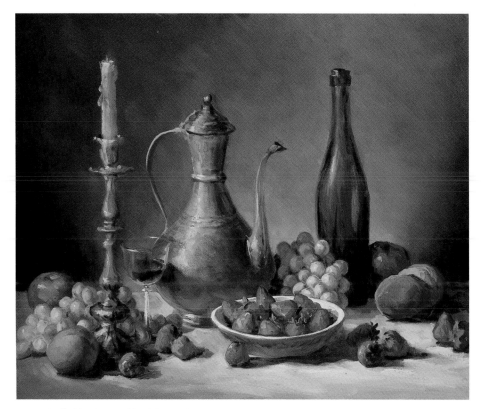

Individual, good-looking color mixtures are really quite easy to make. It's **how** color mixtures act together on a canvas that presents color problems. Colors in compositions won't clash if you make them all the same type of color presentation, such as all warm or all cool. This picture's green background (a cool color) has been warmed so it wouldn't clash with all the warm-colored subjects.

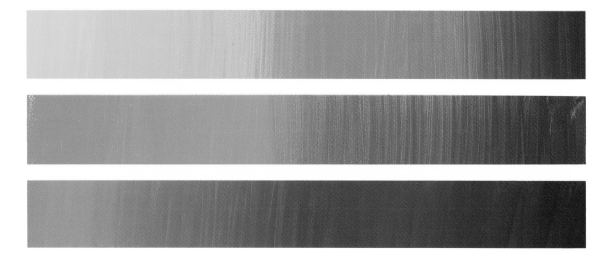

This chart shows the warm colors—yellow, orange and red—in ranges from light to dark. If white were added to each band, the tones would be lighter and their intensities would be duller. Duller, dark tones could be made by mixing them with a dark gray. This is a good exercise for you to do to acquaint yourself with the warm colors.

where there's light there's warmth

1

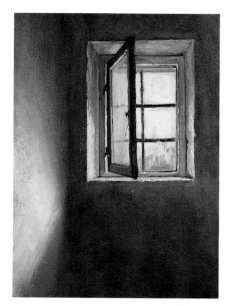

The coloration of the subjects in these three paintings are warm. Their body tone colors were relatively easy to make by mixing white into combinations of warm colors. The illustrations show where cool-colored highlight mixtures were added onto the body tones. **Figure 1** shows how warm and cool colors alternate. Cool highlight (Alizarin Crimson and white) on a warm body tone (Yellow Ochre and white); a cool edge on the cast shadow as it meets the body tone and the inside of the shadow is a warm color again. **Figure 2** shows where a cool, light mixture was added to highlight Gregory's warm-colored hair (Alizarin Crimson and white on Raw Sienna, Yellow Ochre and white). By the way, glazing always comes to the rescue when you are faced with a patterned fabric. I first painted Gregory's plaid shirt as if it were plain red. After it had dried, I added the dark tones of the plaid with a thin glaze of black warmed with Burnt Umber. **Figure 3** shows how I added cooler colors into the warm yellow and orange colors of Italy's old city buildings. Even on cloudy days warm colors have to be slightly highlighted with cool colors. Instead of adding Alizarin Crimson into pure white for sunlight, I added it into gray (black and white).

2

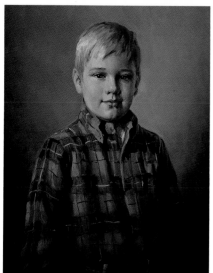

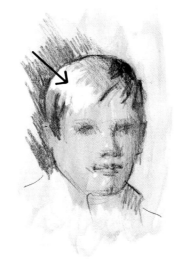

3

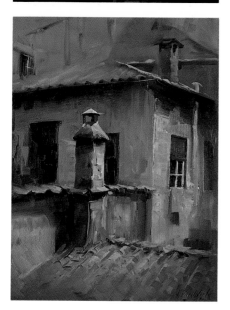

To add a non-technical color note to this page, this is the view I saw from the window in the painting, **Room with a View.** The roof tops are reminiscent of the set that Franco Zeffirelli designed for Puccini's **La Boheme.** Significantly, the room is in the house in Lucca where Puccini was born.

the other yellows, oranges and reds

These descriptions of the other warm colors will help you to substitute, add or avoid using them in color mixing.

yellows

The Yellows:	All the Cadmium yellows are very usable.
Zinc Yellow:	A thick, light greenish yellow.
Naples Yellow:	Avoid. Medium bright, very opaque because today's Naples Yellow is an admixture of yellow pigment and white. It can be mixed.
Mars Yellow:	Avoid. A very opaque color. Much like Yellow Ochre.
Raw Umber:	I don't use it very often in admixture because it is quite weak. Transparent. An okay color but don't count on it as one to shadow colors.
Mars Brown:	Avoid. Similar to Burnt Sienna but very opaque.

oranges

The Oranges:	The Cadmium oranges vary in hue according to their manufacturers. All are usable.

reds

The Reds:	Cadmium Red Medium and Cadmium Red Deep are two colors to **absolutely** avoid. They are expensive and are not a source of the red colors that you think they will produce. In mass tones, they are red looking, but in admixture with white they deaden and become very dull, awful-looking violets.
Chinese Vermilion:	Like Grumbacher Red in hue but far more expensive. Grumbacher Red is just as good. **Note:** When you see a tube labeled ''chrome'' or ''barium'' it describes the kind of pigment not its color characteristics.
Light Red:	Also called English Red Light. Similar colors are Terra Rosa and Venetian Red. **Important:** Don't confuse Light Red with Cadmium Red Light. They bear no relationship to one another.
Mars Red:	Much like Indian Red but even more opaque.

The warm colors of my palette are the least opaque ones available because I use a glazing technique very often. You can't glaze with very opaque colors; even thinning them doesn't make them transparent enough.

20

THE COLOR RED

I singled out red to be featured in its own chapter because red is the most difficult of the three warm colors of the spectrum to paint well. It's a wonderful color to include in a composition; it adds excitement.

The difficulty in painting a red subject is where and when you have to lighten its red color with white. Chances are you expect the mixture to get lighter and brighter only to find that it only gets lighter but not brightened. How disappointing, particularly when your subject's red color looks so bright and light. These light, bright versions of red have to be interpreted rather than literally stated by using a mixture of red plus a bright orange and white instead of resorting to only red plus white.

The problem of painting with red is that most red paints can't withstand the addition of white without becoming dull and, often, a bit violety. Many years ago, there was only one permanent red available that could be lightened with an amount of white and show up light and bright looking. That color was Chinese Vermilion, extremely expensive then, prohibitively priced today. But now, there is a less expensive red paint that can take the place of Chinese Vermilion. It's called Grumbacher Red, which, of course, sounds grossly commercial but, in reality is a splendid, proven red capable of staying true despite great

additions of white. Its red hue doesn't change in admixture with white; its intensity seems to withstand white's lightening power.

Cadmium Reds have been around for a long time. The only one that I use and recommend to students is Cadmium Red Light. While Cadmium Red Medium squeezed from the tube may *look* like the bright, vibrant red you're seeking, any addition of white turns it into an unexpected, unwanted, dull, dense violet. In Cadmium Red Deep, this condition is even more prevalent.

There are many instances in painting when red should be handled with caution. One of them is red's inclination to bleed into another color, and when it does, it *wounds* the picture's effect (that pun *was* intended). In the case of red lips, don't include the red coloration until the very end of the portrait's development. Many little tonal changes have to be made in the area around the mouth, especially the corners, to zero in on an expression. The red coloring could be troublesome, and it is easy to sneak the redness of lips on an already structured mouth.

Red is a strong color, and when it is seen incorporated as part of a subject's coloration, such as in peaches and apples, to name a few, it is the color that should be applied last.

the weaker color first

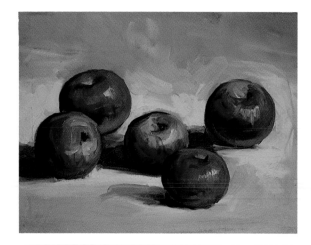

Apples give me a chance to teach another factor of color in action, that of application according to color.

The shape of the apple in the middle of the basket.
◄

The weaker, lighter green color painted in a large area. ►

The stronger, darker red color was used to cut the green down.
▼

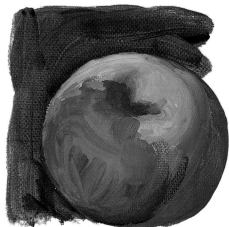

Blend instead of bleed by shaping light tones with dark ones, weak colors with strong ones.

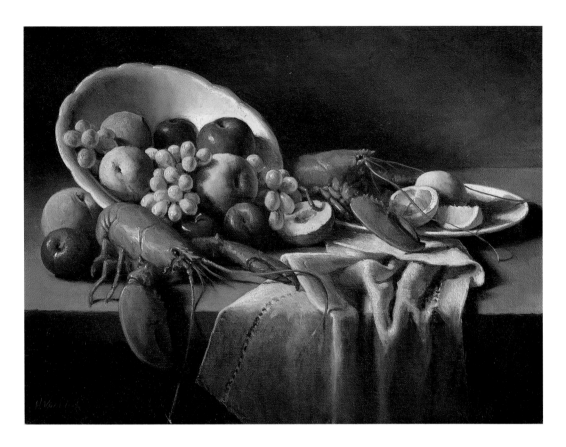

recognizing red's range

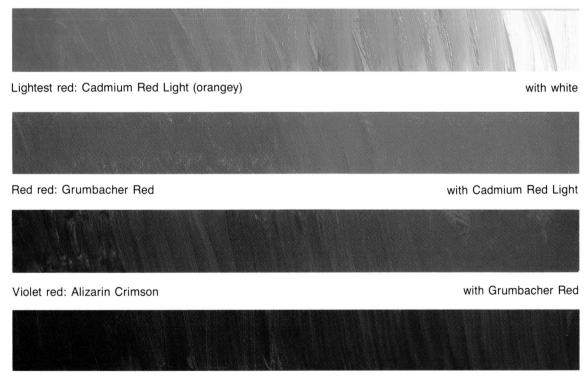

Lightest red: Cadmium Red Light (orangey) with white

Red red: Grumbacher Red with Cadmium Red Light

Violet red: Alizarin Crimson with Grumbacher Red

Darkest red: Burnt Umber and Alizarin Crimson (violetish) with pure Alizarin Crimson

lesson #11
organizing efficient painting time

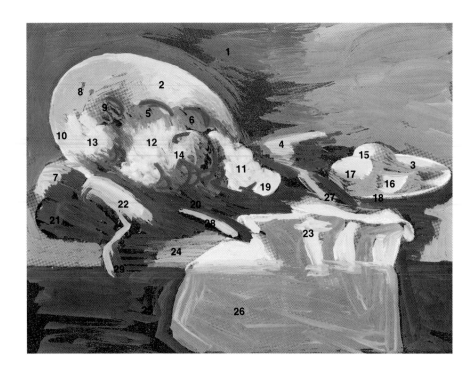

I'm asked by artists and laymen alike: "Do you paint every day?" An artist's life is not a nine-to-five job. I paint when I'm inspired. When that happens to me, which seems to be quite often, I arrange to have no interruptions. My interpretation of my inspiration is dictated by the time I allot myself or the time I happen to have. If I'm inspired by a bouquet of flowers and I know I have only a morning free to paint, I wouldn't be able to do them with the precision and care I used for the lobsters. That kind of interpretation of a subject is well planned rather than spontaneous.

I do an underpainting when a subject imposes an additional measure to the ever-present pressure of time. The lobsters in the still life weren't going to wait forever to be eaten and the cut lemon and peach wouldn't look fresh for days either. Doing an underpainting does not make the painting process take longer, instead it makes it easier, more efficient and less time consuming. A tonal preparation serves to set down the placement, composition and drawing as well as serve as a beneficial base for color.

The other most-asked question is: "How long did it take you to do this painting?" My answer: "A lifetime," always gets a smile of understanding but it's not the one that satisfies their curiosity. Here, then, is the time of each stage of development for the painting of the lobster:

1. **The day before.** Getting the inspiration and cooking the lobsters.
2. **7:30 to 8:30 a.m.** Setting up the still life and lighting.
3. **8:30 to 9:00 a.m.** Placing and proportioning the arrangement on my 14 x 18 canvas.
4. **9:00 to 9:45 a.m.** Doing the underpainting.
5. **9:45 to 10:00 a.m.** Coffee time and drying time for the underpainting.
6. **10:00 to 10:30 a.m.** Glazing of the background, bowl, fruit, lobsters, tablecloth.
7. **10:30 a.m. to 3:00 p.m.** Painting on each subject with light and dark mixtures on top of the wet glazes. Because the glazes are not thick but not running either, they are a joy to work on. They help me ease additions of color onto the canvas and serve as blenders for them. I've numbered the progression of application on the underpainting.
8. **3:00 to 4:30 p.m.** Light and dark accents.
9. **The next day. 8:00 a.m. to noon.** The highlights on the fruit and the lobsters. Reflections in the shadows of the fruit. Detailing the lobster's feelers and legs. The detail of the hem of the cloth.

Few people work at the exact same pace. We have to recognize how our workclock is paced. My pace seems to be a fast one. When you set up time to paint. take your own particular pace into consideration.

21

THE DARKEST COOL COLOR: VIOLET

Much of my instruction about color begins with phrases such as "Artists paint the effect of light," "Make your paint do to the canvas what the light does to your subject" and "Look for the light and the dark." I hope these phrases make you realize that a total understanding of the phenomenon of color will help you interpret the colors you see and will ultimately help you paint better.

Let's study the color violet. For artists, especially landscape painters, violet's importance lies mostly in its role as the complement to yellow. Why? Because *"Artists paint the effect of light."* The light of the outdoors, particularly sunlight, is warm and somewhat yellowish. Violetish coloration, then, can logically represent shade. Since shadowed areas are usually dull versions of violet, they can be quite easily made by mixing most tubed violets into gray.

Quite difficult to interpret, on the other hand, is light shining on violet-colored subjects, principally flowers. Most of the tubed violets are intense only in their medium and dark tones. As soon as amounts of white are mixed into violet paints, their brilliance seems to diminish greatly. Consequently, you must exercise great foresight to avoid the lightening of

violet colors with a lot of white. The range of the bright tones of violet is not as extensive as the ones for the other cool colors, blue and green.

How do you overcome this liability? Choose carefully a background tone that will help you to deal with the color violet more successfully. Avoid a middle-toned background; use a very light one, forcing your interpretation of vibrant violet colors to be dark and intense in relation to it. Or make your background very dark, which will stop you from having to mix a lot of white into the violets to make them light.

No discussion of color can be complete without the few cautions that I feel are important. As a painter, do not let preconceived ideas and emotions influence your use of colors. In the case of the color violet, I'm not saying you must paint violet things even if you don't like the color. I'm saying use violet—and all the other colors, for that matter—as though it is a working part of a painting experience. I, too, have my feeling about violet. It has long been considered the color of royalty and, far worse, the color of death. But on the plus side, its value as yellow's complement can't be brushed aside. And, certainly, violet's a flattering color for blondes to wear, as evidenced by the cover of this book.

rare and royal

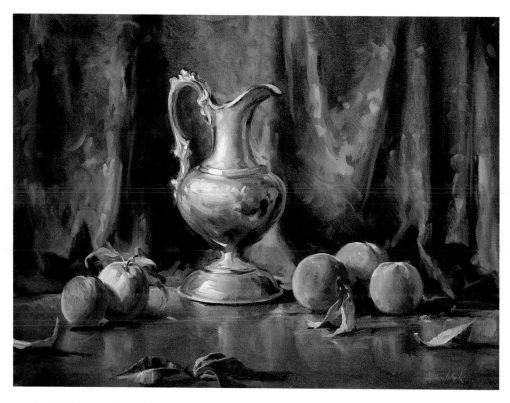

I use muted violet hues for backgrounds. Violet is muted and shadowed with its complement, yellow, but, one wonders, how could yellow, the color of lemons, be used for shadowing and toning down a color? Knowing that Raw Umber and Burnt Umber are really yellows is your answer.

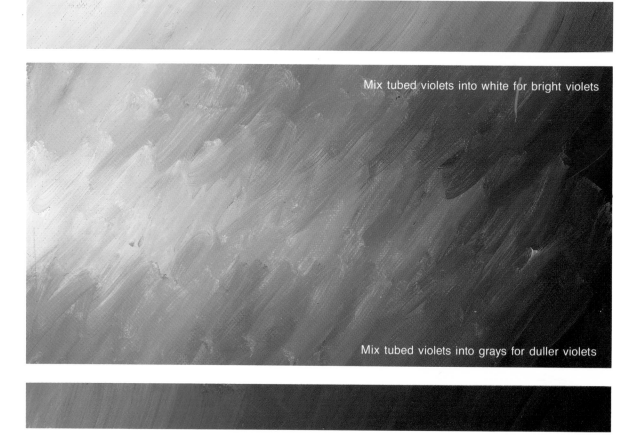

Mix tubed violets into white for bright violets

Mix tubed violets into grays for duller violets

as a color as well as a shadow

Bill Roche was an electrician in town, hence the name **Electric Bill** for my portrait of him. Notice the background, reddish-violet gradated down in tone with darker yellows. I chose it because, for some reason, I thought it would suggest "electricity" as well as fitting his personality. I rejected other background colors for the following reasons: 1) I couldn't use a warm-gray beige because of his hat, vest and pants— all yellows. 2) I couldn't use blue because it would have been boring to repeat the color of his shirt, even with a very grayed blue. 3) I didn't want to use gray either for fear that it would be boring too. 4) I couldn't use tones of orange, a bad idea in any portrait, because they never give skin color the chance to look real. 5) Red was a possibility which I considered using, but, as you can see, reddish-violet was my final choice.

Medium violet, shadowed with Burnt Umber

Dark blue violet, shadowed with Burnt Umber and black

Dark red violet, shadowed with Burnt Umber and Sap Green

the other tubed violets
compared to alizarin crimson

Alizarin Crimson is a wonderful violet color. It's transparent yet strong and very versatile. When it's mixed with black and white it is a source of lots and lots of violet hues, from very muted, when just a little of it is added to light-to-dark grays, and more intense ones, when it dominates the gray mixtures. Strong violet tones can be made by just adding amounts of white. Alizarin Crimson darkens and enrichens all the other reds on the palette. It makes wonderful, muted orange colors when mixed with yellows, from light, when mixed with Cadmium Yellows to dark, when mixed with Burnt and Raw Umber. Many students mistake Alizarin Crimson for a red instead of a violet. Doing so makes many an apple look like the one that "did in" Snow White. Remember, Alizarin Crimson can only be used as a red when other reds are part of the admixture.

Thalo Red Rose. A lighter, more intense red violet than Alizarin Crimson. I do use it on my palette although it is not a workhorse violet; its transparency makes it weak in admixture with more powerful colors. I use it mostly when I paint flowers since its intensity really sings when mixed with white.

Manganese Violet. A dark and lower intensity violet, bluer than Alizarin Crimson. I use it on my palette primarily as the complementary violet to shadow yellows. It makes wonderful dark flesh colors when mixed with Burnt Umber. I love this color because tones of violet are my favorite of the cool colors.

The following violets are ones I hardly ever use:

Rose Madder. Much like Alizarin Crimson, only weaker.

Thio Violet. Much the same as Thalo Red Rose, only bluer.

Ultramarine Red. A very weak, low intensity blue-violet. Use it more as a gray.

Cobalt Violet. A bit more intense than Ultramarine Red.

Mars Red. Very, opaque, low-intensity reddish violet.

helpful hint

> If you paint a lot of flower pictures, search the paint display rack at your dealer for violets. All the manufacturers produce a variety of violets; you could use all the bright ones you can find.

22

THE COLDEST COOL COLOR: BLUE

I can safely say that blue in large areas is the most difficult color to paint. Maybe that's why the English school of painting, Gainsborough aside, said blue should be used just as an accent color to be used here and there.

Blue is the coldest color of the spectrum. Its hue tendency can only tip toward the two other cool colors, violet and green. It stands to reason that it is the complement of orange, the warmest color.

The coldness of blue is what poses the greatest painting challenge, especially as seen in light. The presence of light is automatically the presence of warmth; we all feel warmer in light than in shade. Therefore, where you see a cold color in light you have to warm it up. If you don't, it will look flat, raw, stark. You don't want that, do you? Blue's complement— orange—has to come to the rescue to warm it. This is difficult to do without darkening and dulling the blue or turning it green.

It's a dilemma, all right, having to paint a warmed cold color; it's what makes painting such a challenge for the landscape painter and for the portrait painter, who realizes that blue is such a suitable background color.

When painting somewhat large areas of blue, *handle with care!* A little goes a long way toward making it look too blue and once you have painted it in too strongly, it's pretty hard to kill. It's much better to sneak up on the blueness of the area in question. This can be done by first painting in the area with a gray made of black and white and a bit of orange (Burnt Sienna) in the tone that's a little lighter than the blue area is to be. Then, ease blue into it.

The blue of skies is easier to create if you first paint the sky area with white and Cadmium Orange. Then, disperse blue and white in dabs into that coverage.

I strongly suggest that you do the following experiment with the color blue (it will teach you how important it is to incorporate orange with it): On the upper part of a 16 x 20 practice canvas, paint an area about 8 x 12 of blue that's made of white and Thalo Blue. Then, on the lower part of the canvas, paint splotches of a very light mixture of Cadmium Orange and white, leaving spaces of bare canvas where you can paint in a mixture of Thalo Blue into lots of white. With a large, dry brush blend the orange areas and the blue areas and work them together. Step back to view these two painted areas from a distance and compare their appearance. See if the lower one doesn't look more "real" blue instead of "painted" blue.

the most difficult color in nature

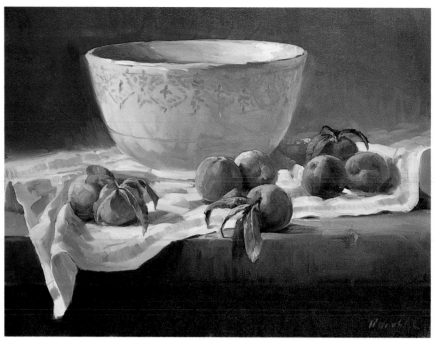

I balanced the blue pattern on the bowl by adding a blue stripe on the white towel. These two touches of blue serve to surround the peaches and accentuate the interest in the picture.

Thalo Blue and white

Thalo Blue and black and white

Many blues can be made by their admixture with white and with light or dark grays.

painting the color blue

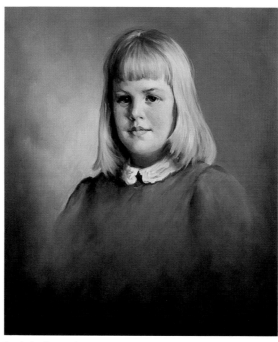

The color swatch on the left shows how raw a gradation of blue looks if the complementary color, orange, is not used in conjunction with it. The swatch on the right was done with mixtures of blue and orange, made of Thalo Blue, white, Burnt Umber and Burnt Sienna. You can see that the background in Rachel's portrait is more like the swatch on the right than like the one on the left.

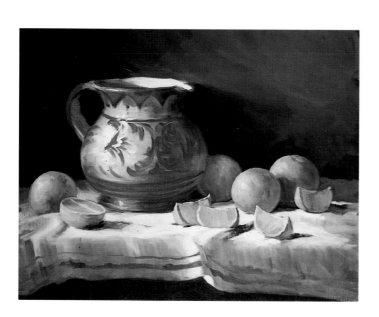
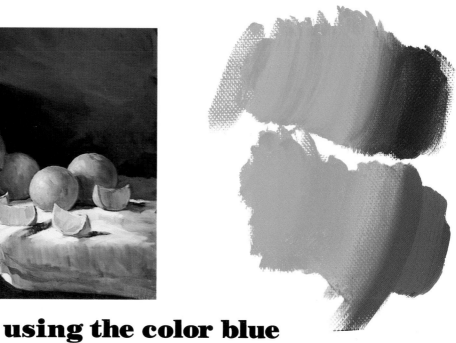

using the color blue

I found this little pitcher in Fiesole, a town near Florence. Here again, I repeated the blue on the white cloth. The top swatch shows how using a bright blue to shadow orange will turn the orange green. The lower swatch shows orange being shadowed by gray blue (Thalo Blue, black and white).

the other tubed blues
compared to thalo blue

Thalo is the proprietary name of M. Grumbacher, Inc. for the pigment **phthalocyanine.** Winsor & Newton's version is Winsor Blue, Shiva's is Shiva Blue, and Liquitex (formerly Permanent Pigments) chooses to call it Phthalocyanine Blue. Any one of them is ideal to use as a basic source of blue; blues made from phthalocyanine are transparent, intense and dark. You can make tones from light and bright (Thalo into a lot of white) to darker, brighter blue (Thalo into less white). Duller tones of blue can be made by mixing Thalo Blue into tones of gray, made of black and white. In fact, most of the hues of the other tubed blues can be emulated by Thalo Blue in admixture with grays and colors.

Prussian Blue. Very much like Thalo Blue. Darker, slightly greener and duller. Very intense, very transparent.

Ultramarine Blue. Also called Permanent Blue in some oil color lines. A violety blue. Not as dark in tone as Thalo Blue and not as strong. Very transparent. Handy for skies in landscape painting and to mix with yellows for various shades of green.

Cobalt Blue. Lighter, less intense than Thalo Blue. Rather strong and not very transparent. It can be matched by mixing Thalo Blue, white and a touch of Burnt Umber.

Cerulean Blue. A light, opaque blue. It might be handy to include on your palette along with Thalo Blue because it's much lighter than Thalo. However, you can match Cerulean Blue's color by adding to Thalo Blue quite a bit of white, Burnt Umber and a mere touch of Thalo Green.

Payne's Gray. Actually, a dull, dark blue that's handy, when mixed with yellows, for landscape greens.

helpful hint

The most common and obvious use of blue is for water and skies. The most common mistake in painting them in these areas is to make them too blue. You have learned how to control a color's intensity by using gray or the color's complement. When painting water and skies, make sure you realize that the flat of the canvas is where you are trying to record miles of sky and water. Their tones and colors, therefore, have to look far away and close by. Judge the tone and intensity of the far-off water by comparing it to the water in the foreground. To make your skies look more dimensional, look at the color of the sky directly above you and incorporate it into your sky's color at the top of your canvas.

23

THE WARMEST COOL COLOR: GREEN

Green has a wide range of tone because it's a mixture of a dark spectrum color — *blue* — with the lightest color of the spectrum — *yellow*. Its range of intensity is also extensive. Green's temperature can vary from very cool blue greens to very warm yellow greens. Probably green's vast scope of hues, tones and intensities is why so many students wail, "I have a lot of trouble mixing the right green."

Most of the greens seen in nature are yellowish in hue. For this reason it's better to add amounts of a tubed green paint into a yellow instead of adding yellow into green.

There are many tubed greens from which to choose. *Thalo Green's* very dark tone yet brilliant intensity makes it the most versatile one of them all in admixture with other colors. Being very dark it never needs to be darkened, yet offers the widest range of tone by additions of amounts of white. Its blue hue can be yellowed with many different yellows: Thalo Green and Burnt Umber for dark yellow green to Thalo Green and Cadmium Yellow Light for light, bright yellow greens. Even lighter versions of these greens can be made by adding white to them. A tubed dull color can't be intensified and it confers its dullness on everything with which it's mixed. Thalo Green's beautiful, strong intensity can be dulled, muted and toned by admixture with its complement,

red. Therefore, the more intense tubed color is the more versatile one to use in admixture.

Thalo Yellow Green is such a handy color to have to supplement Thalo Green, since it is so light and yellow in relation to it. *Sap Green*, too, serves as a convenient supplement to Thalo Green, because of its more medium tone and intensity.

Blue greens are seldom seen in nature. They play decorative roles but are often seen in skies. In fact, if you were to add a mixture of Thalo Green and white in patches to a sky, you would lend a warm relief to a sky that looks too blue.

Green is often referred to as nature's background color, and can be used often as background color for flowers, still lifes and portraits. Especially suitable are the greens that are medium in tone, yellow in hue and muted in intensity. These types of greens can be mixed by adding Thalo Green into a tone made of black and white and then adding one of the oranges of the palette: Cadmium Orange, Raw Sienna or Burnt Sienna. Very grayed versions of these types of green can also be made by adding a little red into the mixture.

Since most greens are yellowish ones, you'll have to use red violets as their complements to gray or shadow them.

shadowed greens

Sunlit greens become more yellowish in hue. Don't be afraid of adding white to a sunlight mixture. Shadowed green mixtures must have some kind of red violet in them to make them look natural.

Thalo Yellow Green and white — Thalo Yellow Green, Sap Green and Alizarin Crimson

Sap Green, Yellow Ochre and white — Sap Green, Yellow Ochre and Alizarin Crimson

Yellow Ochre, Thalo Green — Thalo Green, Burnt Umber and Alizarin Crimson

landscape greens

Tones of Thalo Yellow Green and white

Tones of Sap Green and Cadmium Yellow Light

Greens made of Thalo Green or Sap Green and orange

Greens made of Thalo Green or Sap Green and Burnt Sienna

helpful hint

You can avoid making your greens too green by always adding the tubed greens into puddles of yellows and oranges. When making greens out of yellows and blues, add blue into a puddle of yellow.

If you paint a scene where there are a lot of greens, search out the darkest one, compare it to the lightest one and mix both tones next to each other on your palette. This is the best way to stop you from making all the greens the same—for instance, the green of the evergreen tree compared to the sunlight on the grass.

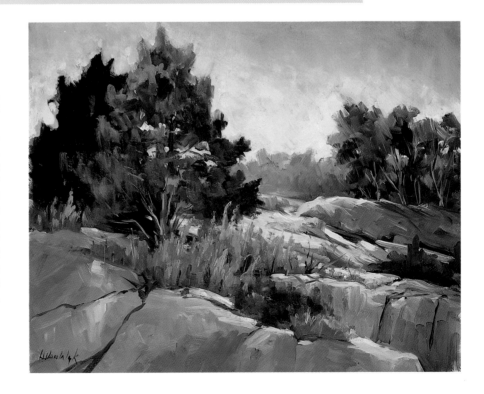

other tubed greens compared to thalo green

All the information about Thalo Blue also applies to Thalo Green. It's a trade name, it's transparent, dark and intense. In admixture with tones of gray, many lovely hues of blue-green can be made. The difference between Thalo Green and Thalo Blue is that green colors get more yellow in hue as they get brighter; to lighten and brighten Thalo Green, white and yellow have to be added to it instead of adding just white.

Thalo Yellow Green. Very light and very yellow. I love this color because it's so opposite from Thalo Green.

Sap Green. Although I can mix this hue with Thalo Green, Burnt Sienna, Cadmium Orange and white, I find a tube of Sap Green handy, enjoying the transparency that's not possible with my homemade mix due to the addition of opaque white and opaque Cadmium Orange.

Viridian. Lighter in tone, less intense and yellower than Thalo Green. Mixed with any of the yellows, Viridian makes grayer versions of the ones that Thalo Green and yellow make. Transparent but weak in covering power. Thalo Green is more economical to use than Viridian because in admixture, a little Thalo Green goes a long way.

Permanent Green Light. An opaque, more medium-toned green than Thalo Green. I never use this color. It makes sense to me to have the darkest versions of color on my palette because I can always make lighter versions of them by adding white.

Chromium Oxide Green. A very opaque green which makes it very strong in covering power. Mix with Burnt Umber, Burnt Sienna, Yellow Ochre, Cadmium Orange or Cadmium yellows for natural looking greens. Good for painting outdoors.

Green Earth. Although the colors look somewhat alike, Green Earth's characteristics are just the opposite of Chromium Oxide Green. Green Earth is very transparent and very weak. Not at all suitable for landscape painting even though it's **earthy** looking. Green earth is used mostly by the portrait painter who needs to make fragile changes in flesh mixtures.

24

IN CONCLUSION: THE COLOR GRAY

Gray really can't be called a color; it's a *condition* of a color. We see grayed versions of all the colors in many, many tones. There are, however, as you are aware, some things that we can actually call *gray*. One of them, the most obvious for the still life painter, is pewter. The most obvious example of a gray in nature is fog.

Gray, though, imposes a much deeper importance in painting than recording pewter and fog; it has the capacity to make our paintings look atmospheric and our colors look real. When color mixtures are infused with their complements, a special kind of gray condition makes the mixture more suitable looking. Using warm and cool colors next to each other, through the use of a color and its complement, imparts the gray condition that looks right. To explain:

1. *A red apple.* Its highlight is *cool green* on the *warm red* body tone. The edge of the shadow is *cool green* and the shadow itself is *warm red.*

2. *Skin.* Its highlight is *cool* flesh on *warm* flesh. The shadow's edge is *cool;* the inside of the shadow is *warm.* The cast shadow's color is *cool* with *warm* color in it.

3. *Sky.* Blue warmed with orange, making its color atmospheric gray.

As you can see in the examples just cited, there is a condition of grayness that's important to rendering the realistic color of things. My final, very simple color mixing advice is: *When in doubt use gray* for those doubtful-looking colors. Beautiful ones can be made by mixing black, white and a color. Beautiful grays are known to be made by mixing a color and its complement. And those who refuse to use black will have to do a lot of mixing of the two colors into amounts of white to adjust the mixture's tone value. I think it is easier to establish a tone value of gray with black and white and then impart color into it. After all, by now you realize that the tone of the color is extremely important. Doubtful-looking colors are usually the ones effected by shadow. I find the use of black in admixture makes getting the right tones of colors easier. I can do so without a lot of experimental mixing which has a tendency to deaden mixtures. I'm aware that the purists will not use black; I do, and just gave you good reasons why.

On the other hand, there is no doubt about those colors seen unaffected by shadows and they shouldn't be mixed into gray. Definite colorations are usually seen in light so a somewhat oversimplified formula for colors in light is color into white. These mixtures are best made by moving an amount of white into the mixing area of your palette and adding color into it. The mixtures will sparkle more if they are not over-mixed.

Some words of summation: Colors in shadow are colors into gray; colors in light are colors into white. Is color mixing that easy? In a way, yes.

gray is everywhere . . .

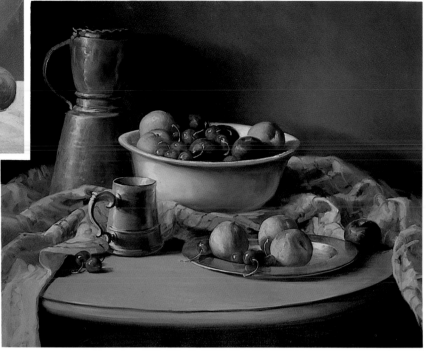

The arrangement of fruit with gray background and tankard shown above is a simplified version of the more elaborate still life. I did it (the simplified one, that is) on my television show to demonstrate how gray shows off color. I find that students swamp their paintings with too many colors instead of balancing the presence of color with somewhat colorless areas.

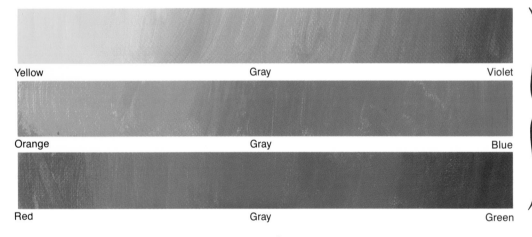

Yellow	Gray	Violet

Orange	Gray	Blue

Red	Gray	Green

Warm colors are grayed with cool colors

gray is warm and cool

Cool colors are grayed with warm colors

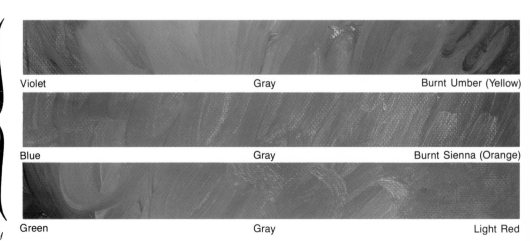

Violet	Gray	Burnt Umber (Yellow)

Blue	Gray	Burnt Sienna (Orange)

Green	Gray	Light Red

gray is colorful

Foggy weather, misty meadows, fuzzy peaches, hazy mountains, dewy grass. Paint's answer to these effects is GRAY!

Various warm colors into black and white **Various cool colors into black and white**

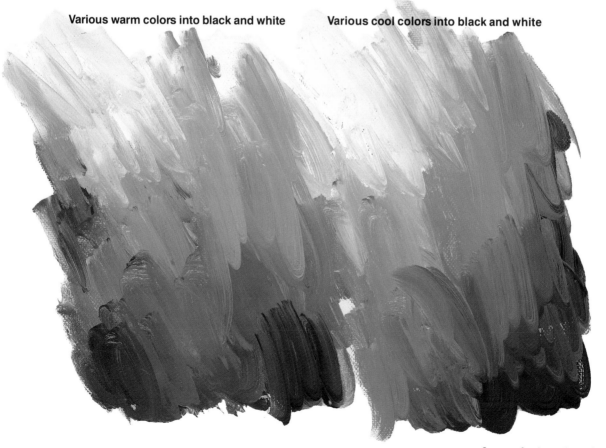

tubed whites

Tubed whites—lightening agents for color:

1. **Zinc White.** A clean tinting, slow-drying white. The portrait painter's favorite.

2. **Titanium White.** A strong tinting white, suited to all types of painting.

3. **Flake White.** A very heavy white white. Has to be greatly thinned for ease of application.

4. **Soft Formula White.** Permalba White, Superba White, Winsor White, Ultrawhite, are all commercial names for juicy whites made of zinc and titanium combined. There are many trade names for whites that are all reliable. Use one that's fluid and soft enough to mix easily with your colors.

Technical Helpful Hint: Since white is very slow drying, it should be used mostly in the finalizing mixtures. This is easy to do because the lightest light tones are best added last.

tubed blacks

Black—the darkest tone of paint available:

Ivory Black. A neutral, clean transparent black. The only one I use.

Mars Black. A warm, opaque black. Too overpowering to use with colors.

Lamp Black. A cold, very opaque black. Too overpowering to use with colors.

mediums

My mediums. For general painting, I use turpentine. It's not that I actually mix it with my paint; I dampen my brush with it to ease its flow on the canvas. My brush is constantly damp from cleaning it in turpentine between mixtures. If I have to thin my mixture, I use a medium made of linseed oil, damar varnish and turpentine (equal parts of each). I use this medium to thin my paints for glazes. Painting outdoors, I add some linseed oil to the can of turpentine. I clean my brush in this from mixture to mixture; it makes my mixtures more spreadable.

At times, I will apply paint with painting knives for effects that I think are easier to get than with brushes, like stroking flashes of sunlight or lines seen in books or rooftops or masts on boats. Painting knives (or palette knives, as some people refer to them) only apply light tones well because light tones are thick. Many beginners find knife painting fun; and their paintings look better than the ones they do with brushes mainly because **they use more paint.**

varnishes

There are two reasons for varnishing a painting. First, and probably the more important one, is to make the surface shine enough to have the painting show off its true colors. Waxing a floor makes its color rich looking because the wax makes the surface shiny. Since many oil colors dry with a matte finish—some more than others—a thin coat of varnish adds a shine and evens out the irregularities of the surface's appearance.

The second reason for applying a varnish is to protect the oil paint surface from dirt, especially in the polluted atmosphere that seems to abound in this modern era. A soiled varnished surface can be quite easily removed when compared to cleaning off dirt that has gathered on the paint film of your picture. For this reason, a soft resin type varnish, such as damar (one that is readily dissolved) should be used instead of copal, a hard resin type varnish.

It is not a good idea to apply a thick coat of varnish to a painting; it can contract during temperature changes resulting in so-called cracking. Many painters worry about their painting cracking when they should also worry about cracking varnish. Keep in mind that cracks will show up more on paintings done on stretched canvas than on those painted on rigid supports. I have a painting by M.A. Rasko (my mentor) that he did in 1939 on a canvas board. It is in excellent condition, whereas a self portrait that I did on a stretched canvas under his instruction in 1949 had to be restored thirty years later. Same paint, same technique, same everything, except the surface.

If you want to study varnishing "in depth," as they say, and want to get all the information you possibly can about the subject, you'll want my book, **Your Painting Questions Answered from A to Z.** In it, I cover varnishes, varnishing, cracking, rigid supports, etc., in great detail.

For an uncomplicated procedure for varnishing a painting, I heartily recommend a spray varnish that you can use soon after completion of the picture to enrich your colors. The tiny "dots" that the spray emits won't completely coat your painting, thus ruling out cracking of any kind; the spray just adds the necessary shine (of course, you must not flood your painting's surface with spray varnish. A light coat will do nicely).

Three to six months after your painting has been completed, you'll want to give it a "final" coat of varnish.

1. Lay your canvas on a flat surface.
2. Soak a lint-free cloth with varnish (damar, of course).
3. Apply rather quickly in a circular, smooth motion, starting in the center of the canvas. Do not flood the varnish on.
4. Do not use a brush for this application. Doing so will apply too much varnish and will apply it unevenly because of the overlapping strokes that are so characteristic of a brush. Since varnish is fairly fast drying, a brushed-in area can begin to dry before you can overlap into it.

I know that there is a lot of information around about how to make a painting last. I think the best way is to try to paint so beautifully that it will be cherished and well cared for. Even paintings done with haphazard techniques seem to be strong enough to last for years and years. The question is "are we painting for posterity or just doing the best that we can?" What is **your** answer?

welcome to my studios

Photo by WMHT-TV

Through the years, artists' studios have been a source of fascination for many people. For students, the interest is obvious; I've studied the expressions on their faces whenever any of them have come through my studio. I've also noticed the reactions of non-painting visitors. Most of them fully expect a full-blown Bohemian environment: a disorderly mess of paint-clogged palettes, paint spills and neglected brushes strewn about. How surprised they are to see everything in order! Some are actually disappointed because they think artistic expression is inhibited by discipline. On the contrary. In my four decades of being around artists, I've never encountered a studio that hasn't been a well arranged working place. Some, extremely neat; some, casually kept, but nevertheless well organized and ready to meet freely and comfortably the challenge of a new canvas.

Pictured here is my studio that's situated in the television studios of WMHT in Schenectady, New York, producers of my series, *Welcome to My Studio*. I feel at home working in it because it was fashioned to be much like my own studio in Rockport, Massachusetts. Although the light that comes in through the "north window" is not daylight but artificial, it provides me with the contrasts I need to shape the paintings I do for the three cameras that tape my shows. These cameras are stationed on the open side of the studio set: one is fixed on my subject, one on my canvas, and the third is there for me to turn to when I want to address my audience.

I've had many studios. The first one was in the room that I had initially outfitted as a dollhouse. As my interest in painting grew, I managed to expand my studio until it took up the entire basement, especially the carpentry shop that I used to work in before I started to paint. Later, in the late forties, my studio was in a separate building that my father and I built. It had a large north window and a high domed ceiling to accommodate the big, antique easel that I still use (shown on the cover of my book, *Welcome to My Studio).*

In 1968, I designed my house and studio. The studio is not an isolated room, as many people think studios have to be. Mine is the major part of our living area, because it is so much the major part of my life.

Your place to work doesn't have to be large and elaborate; just enough space for an easel and taboret for your supplies with adequate lighting to paint by. Subject matter can be lighted by a spotlight that you can view at least four feet away from your place at your easel. The most important function of your studio should be its ready accessibility. Art supplies stored away in a closet don't encourage and invite you to paint enough. Painting is enjoyable, but it is work, just as it is with other kinds of endeavors; the getting started takes effort. When effort has to be used to set up a working place, fragile inspirations may never get onto a canvas.

Show Title	Painting	✳ CMinA Chap	✳ WTMS Chap
v series 1 HOW TO BEGIN	A Dutch pot	14	1
THE HIGHLIGHT	Glass bottles	3	9
A PORTRAIT	Portrait of a man	6	20
COMPLICATED TEXTURES	Baskets	4	21
THE BEAUTY OF METALS	Copper bucket	5	12
BACKGROUNDS	Flowers with calligraphy	10	7
THE FOCAL POINT	Books	8	13
BRUSHWORK	Red onions, black cooking pot	5	5
THE TECHNIQUE OF THE MASTERS	Oriental theme with brass tray	17	22
PAINTING APPLES	Red and green apples	20	22
OVERLAPPAGE	Statue of Venus de Milo	14	15
CAST SHADOWS	A crock and apples	4	8
PROGRESSION OF APPLICATION	An Italian gate	16	15
v series 2 POSITIONING THE SUBJECT	A landscape	23	1 &13
UNDERSTANDING DIMENSION	Flowers	9	2
PAINTING HAIR	A female model		14
THE COLOR GRAY	Still life with pewter	24	4
SHINY SURFACES	Reflections in still water	18	5
BASIC COLOR MIXING	Still life with lettuce	2	
PAINTING SILVER	Roses and a silver container	5 & 11	12
HOW TO PAINT EYES	A self portrait	7	10
EXCITING BRUSHWORK	A seascape	16	5, 11 & 23
THE COLOR WHITE	Eggs	3	17
PAINTING DRAPERY	A still life with gold drapery	13	16
FORESHORTENING	Still life of books	15	
A PORTRAIT SKETCH	A young woman	7	10, 14 & 20
v series 3 AN ELLIPSE	Basket of tomatoes	15	8
TRANSPARENT GLASS	A wine decanter	3	9
LANDSCAPE COMPOSITION	A snow scene	18	
A SUBJECT AND ITS BACKGROUND	A woman's portrait	6 & 12	20
COLOR & ITS COMPLEMENT	Red and green peppers	4	17
IMPRESSIONISM	Still life	24	
TROMPE L'OEIL	Potted geraniums in window	4	19
SHAPING WITH BRUSHWORK	A portrait in profile		15
PAINTING YOUR PET	A West Highland Terrier		14
SHINE AND SHAPE	Brass coffee pot	5	12
THE UNDERPAINTING	A painting of roses	11 & 17	18
PERSPECTIVE	A country lane	15	
A FACTOR OF COMPOSITION	Clay pots	9	13

✳ **CMinA Chap & WTMS Chap:** Represents the chapters in this book and *Welcome to My Studio*, which either pictures the painting or deals with the theme of each television show that I've listed above.

books and tapes by helen van wyk

As the author of eight books on the subject of painting, I'm often asked by amateur artists and painting beginners, "Which book do you think would be most helpful to me?" My answer: "How much help do you think you need?"

Being able to paint as well as you want is a constant pursuit. As you all know, I studied with Rasko. Five years after my apprenticeship with him, I attended one of his lectures on painting; I couldn't help but *marvel* at how smart *he* had become over those past five years.

Wanting to paint well can be an *anxious* pursuit as well, especially if you have unrealistic expectations about each new painting that you complete. This anxiety can be overcome and replaced by a practical, positive painting experience by trying to make each painting better than the best one ever. Furthermore, don't try to completely overhaul each new painting. Instead, direct your attention on improving only one facet of the painting process as you enjoy your involvement with each picture.

Fortified by letters from readers of my books, I am confident that the information will help you gain new insight about painting, help you direct your study of painting and help you paint better pictures.

Successful Color Mixtures. Easy-to-follow color mixing instructions written in "cookbook recipe" style. Contains instructions for mixing the color of 120 different subjects in portraiture, still life, florals and landscape. This is the work book you can have at your easel for personal reference. 200 pages, 8½ x 11, 72 black-and-white illustrations. ISBN 0-929552-00-8.

Painting Flowers the Van Wyk Way. Concise instruction on more advanced oil painting techniques. A close examination of the factors that make artistic interpretation of any subject possible to a greater extent. 120 pages, 8 x 11, 136 illustrations, 22 pages in full color. ISBN 0-929552-02-4.

Portraits in Oil the Van Wyk Way. 44 full-color illustrations along with text that are designed to help you paint better portraits. Practical instruction on color mixing of skin, hair, backgrounds and the complexities of blending and modeling shadows and the shapes of the features. 128 pages, 8½ x 11. ISBN 0-929552-03-2.

Basic Oil Painting the Van Wyk Way. An oil painting classic! 134 pages with 52 illustrations that explain the principles of painting simply yet completely. A must for beginners! ISBN 0-929552-01-6.

Your Painting Questions Answered from A to Z. Helen Van Wyk's answers to students' questions make this a helpful, beneficial reference book. It clarifies the use of all oil painting materials. Dictionary format. 200 pages, 106 illustrations. ISBN 0-929552-04-0.

Welcome to My Studio. A beautifully illustrated book on the art of painting. It enlightens, acquaints, clarifies and teaches painting. Even non-painters find the information interesting. 128 pages, 8½ x 11. 248 illustrations, 94 in full color. ISBN 0-929552-05-9.

Video Tapes

Oil Painting Techniques and Procedures. Two hours of closeup instruction, from the placement of the composition to the finishing touches. VHS only.

Painting Flowers Alla Prima. One hour of direct painting, with daisies as the subject. Stunning closeups put you on the end of the artist's brush. VHS only.

The Portrait: Step by Step. In one hour's time, the artist finishes a portrait in oil. Brilliant photography; masterful commentary by artist Van Wyk. VHS only.

Art Instruction Associates • 2 Briarstone Road • Rockport, Mass. 01966 • (508) 546-6114